modern gothic

modern gothic

The
Revival
of
Medieval
Art

Susan B. Matheson
and Derek D. Churchill

Yale University Art Gallery
New Haven 2000

Published in conjunction with *Modern Gothic: The Revival of Medieval Art,* an exhibition organized by the Yale University Art Gallery

Shown at the Yale University Art Gallery, New Haven, Connecticut
4 April – 30 July 2000

Time for Ideas
The programs of the Connecticut Humanities Council

This project is supported by a grant from the Connecticut Humanities Council.

This catalogue was created from materials originally presented at the Yale University Art Gallery in the course of the project *Modern Gothic: The Revival of Medieval Art,* sponsored by the Yale University Art Gallery. The project was supported by a grant from the Connecticut Humanities Council. The viewpoints or recommendations expressed here are not necessarily those of the Council.

Cover: A.J. Davis, Lyndhurst (1865), Tarrytown, New York, A National Trust Historic Site (photograph Susan B. Matheson)
Back cover: Henry Austin, *City Hall, New Haven, Connecticut* (1861), watercolor, Whitney Library, New Haven Colony Historical Society, cat. no. 44 (photograph Carl Kaufman)

ISBN number 0-89467-090-5

Designed by Nathan Garland Graphic Design, New Haven, Connecticut
Printed by Hull Printing Co., Inc. Meriden, Connecticut

Contents

Lenders to the Exhibition

Avery Architectural and Fine Arts Library, Columbia University

Beinecke Rare Book and Manuscript Library, Yale University

Branford College, Yale University

Mr. & Mrs. Richard Derringer

The Metropolitan Museum of Art

The New Haven Colony Historical Society

The New York Historical Society

Stephen Parks

Sterling Memorial Library, Manuscripts and Archives Collection, Yale University

Yale Center for British Art, Yale University

Lewis Walpole Library, Yale University

A Private Collection

A significant benefit of residing in Connecticut and working at Yale is the opportunity to live with interesting and beautiful architecture. From the white clapboard churches and early colonial houses to the buildings of America's foremost modern architects (creations by Louis Kahn, Paul Rudolph, Eero Saarinen, and many others), the state and the university offer a feast for the eye. *Modern Gothic* celebrates an important phase of that rich architectural history, the Gothic Revival. Immediately familiar to us in college buildings and churches statewide, the Gothic Revival style pervades museums, houses, and cemeteries as well. Indeed, it is all around us, juxtaposed in surprising ways with traditional and modern New England architecture. To shine a light on this architecture, and to encourage people to visit, appreciate, and preserve it, are primary goals of this exhibition.

Foreword

Architecture, of course, embodies the society that built it and the values by which that society lived. *Modern Gothic* holds a mirror to mid-nineteenth century America and Britain, reflecting the Gothic Revival in the social and historical context in which it flourished in its most original and coherent form. By exploring the architects, patrons, and contemporary writings surrounding the Gothic Revival, and the buildings themselves, the exhibition demonstrates a philosophical basis for the style that was fully consistent with and expressive of the thought of its time. Chosen for some of the most prominent civic buildings, churches, and houses of its day, the Gothic Revival style, like the Greek Revival style before it, came to embody British and American ideals and to serve as a visible symbol of them. *Modern Gothic* reveals the significance of the Gothic Revival to nineteenth-century society. It also argues that since the ideals that inspired the style then remain part of our life today, the Gothic Revival remains modern as well.

We are particularly grateful to Susan Matheson, the Molly and Walter Bareiss Curator of Ancient Art at the Yale Art Gallery, for conceiving and organizing this ambitious exhibition and its accompanying publication. We also extend warm appreciation to the Connecticut Humanities Council for its generous grant in support of the project. The links forged between the exhibition and New Haven and other Connecticut communities are strong, and we have welcomed the opportunity to work with the New Haven Colony Historical Society, the New Haven Preservation Trust, the International Festival of Arts and Ideas, the Connecticut Trust for Historic Preservation, and the Connecticut Historical Commission on various aspects of the exhibition and its programming. Through our focus on Gothic Revival architecture that can still be seen today, we hope to complement the good work of these organizations, as we celebrate some of the treasures of our region.

Jock Reynolds
The Henry J. Heinz II Director

Introduction and Acknowledgements

This exhibition, a sequel to the Art Gallery's neoclassical exhibition in 1992, explores the other protagonist in the great style war between Greek Revival and Gothic Revival art in the mid-nineteenth century. Like *Noble Simplicity and Silent Greatness*, as the earlier exhibition was called, *Modern Gothic* explores an art historical movement from the perspective of social and intellectual history. Both revival movements began in Britain in the eighteenth century, and both played significant roles in nineteenth-century America. Both are reflected in architecture, art, and literature. Both embodied an idealism that survives in America today.

The Gothic Revival was a complex movement. It contained elements of the romantic and the picturesque in its affinity for the medieval castle style, in its fascination with ruins, and in its choice of sites for its buildings. It looked back to roots in English medieval art, to old English stories and legends, to old church rituals, and to the medieval monastic communities that became universities. It looked forward to the expanding intellectual and social aspirations of an increasingly wealthy and cultured population. It expressed ancient strivings for liberty and independence, and modern philosophies of individualism and self-reliance. It had links to transcendentalism and westward expansion in America.

Modern Gothic focuses on the Gothic Revival in the mid-nineteenth century in Britain and America. Through the study of the art and architecture created in this style, the patrons who commissioned it, and contemporary writings endorsing it, the exhibition seeks to reveal the reasons for the Gothic Revival's popularity in its own day. By offering a sampling of the Gothic Revival architecture that still stands in Connecticut, New England, and neighboring states, *Modern Gothic* shows that this revival of a venerable style does indeed remain timely. If the exhibition helps visitors understand the context of the movement and encourages the appreciation and preservation of its monuments, it will have succeeded.

My first and greatest debt is to Derek Churchill, my collaborator on this project from the beginning. He has been an engaged and dedicated co-curator, and working with him has been both intellectually stimulating and a real pleasure. Britain has no more staunch defender. I could have asked for no better colleague.

An exhibition curated by two outsiders, such as this one, incurs more than the usual debts to the scholars in the field to whom we constantly turned for advice. At the same time, the usual statement that such advisors bear no responsibility for errors of fact or judgment is in this case more than mere convention. Many individuals have been particularly generous with their knowledge and encouragement and it is our pleasure to thank them here. First and foremost, we are grateful, on American architecture, to William H. Pierson, Jr. and on Pugin, to Stephen Parks for their unparalleled generosity with their ideas and scholarly resources. Jane B. Davies kindly shared her enormous expertise on A.J. Davis; it is my great regret that she did not live to see the continued homage to Davis and to her own work in this exhibition and catalogue. For expert guidance we also thank David Barquist, Elizabeth Mills Brown, Walter Cahn, James Campbell, Leslie Preston Day, Edward Franquemont, Janet Parks, and Scott Wilcox. For archival assistance with American architecture I thank James Campbell and Amy Trout (New Haven Colony Historical Society), Edward Franquemont

and Edward Bottomley (New Haven Preservation Trust), Beth Savage (National Register of Historic Places), John Herzan (Connecticut Historical Commission), Greg Galvin (Connecticut Trust for Historic Preservation), Judith Schiff, (Manuscripts and Archives Collection, Yale University), Elise K. Kenney, Victoria Solan, and Katherine Lynn, and the helpful staff at numerous libraries, historical societies, and churches in the northeast.

We are especially grateful to the following lenders, whose generous responses to our loan requests made the exhibition possible: *private collectors:* Stephen Parks, Mr. and Mrs. Richard Derringer, and an anonymous private collector; *in New Haven and New York:* The Metropolitan Museum of Art (Philippe de Montebello, George Goldner, Heather Lemonedes); Avery Architectural and Fine Arts Library, Columbia University (Janet Parks); The New York Historical Society (Kimberly Terbush, Holly Hinman); The New Haven Colony Historical Society (James Campbell, Amy Trout); *at Yale University:* The Yale Center for British Art (Patrick McCaughey, Malcolm Warner, Scott Wilcox, Theresa Fairbanks-Harris); The Beinecke Rare Book and Manuscript Library (Ralph Franklin, Stephen Parks, Gisela Noack); The Lewis Walpole Library (Richard Williams, Ralph Franklin, Joan Sussler); Manuscripts and Archives Collection, Sterling Memorial Library (Judith Schiff); Branford College (Master Stephen Smith). We offer warm thanks to our curatorial colleagues within the Yale University Art Gallery for sharing their collections and their expertise: David Barquist, Helen Cooper, Richard Field, Robin Jaffee Frank, Lisa Hodermarsky, Patricia Kane, and Joanna Weber.

Our heartfelt thanks go to our talented colleagues at the Gallery for their tireless and good-spirited support, especially: Registrar's Office: Sue Frankenbach, Lynne Addison; Installation: Clark Crolius, Kris Sabatelli, David Norris; Diana Brownell for matting and framing; Business Office: Louisa Cunningham, Charlene Senical, Mary Ann Tomlinson; Conservation: Mark Aronson, Patricia Garland; Public Relations: Marie Weltzien; Museum Shop: Howard el-Yasin; Programming: Mary Kordak, Ellen Alvord; Program Coordination: Linda Jerolmon; and in my department, Jonathan Garland, especially for the walking tour brochure and for finding the Rogers model of Harkness Tower. My special thanks go to Kathleen Derringer for her professionalism, tenacity, and vigor in pursuit of funding for the exhibition. Thanks also to Sarah Parcak, Patricia Garland, David Anderson (through the kindness of Chris Kenney), and Jonathan Garland for photographs and to Sarah Nunberg for object conservation.

It is a pleasure to thank Nathan Garland for his thoughtful and elegant design of this catalogue and for the delightful collaboration from which it grew. His sensitivity to the material, his knowledge of every aspect of design and its history, and his extraordinary eye are evident on every page.

We offer particular thanks to the Connecticut Humanities Council for their generous support of the project and to Laurie McCallum Raynor and the members of the review committee for their constructive and helpful suggestions. Finally, we are grateful to Paul Collard, President, International Festival of Arts and Ideas, for helping us link the exhibition to one of New Haven's premier cultural events.

Susan B. Matheson
The Molly and Walter Bareiss
Curator of Ancient Art

A Gothic Renaissance in Modern Britain

Derek D. Churchill

Charles Locke Eastlake first published his account of the "Gothic Revival" in 1872, and for more than a century the anglophone world has used this term almost exclusively to identify the resurgence of interest in the Middle Ages during the eighteenth and nineteenth centuries.[1] Indeed, this movement first took hold in Eastlake's native Britain, where the Gothic past was not so far removed as it was on the Continent. Long an importer of artistic trends forged in Italy, the Netherlands, Germany, and France, Britain quickly assumed the leading role in the Gothic Revival, making it "perhaps the one purely English movement in the plastic arts."[2] This was only one of many revivals that punctuated artistic life throughout Europe in the eighteenth and nineteenth centuries, from the exotic forms of *chinoiserie* or the Egyptian Revival to other periods in the long history of medieval art, including both Byzantine and Romanesque.[3] But in the end, the famous "Battle of the Styles" would be waged between Classical and Gothic art. Since the Renaissance, Classicism had never fallen out of favor, and both English Palladianism and the Neoclassical movement of the eighteenth century only reinforced the high esteem accorded to works in the Greek or Roman manner. The most adamant partisans of Gothic were hoping for an anti-Renaissance, one in which modern Europe would realize that the Middle Ages were not the Dark Ages, but rather a Golden Age.

The Survival and Revival of "Gothick"

Ironically, this so-called revival may not even have been a proper revival at all, since the construction of Gothic buildings apparently never abated between the late Middle Ages and the nineteenth century. Architectural historians usually account for this continuity by distinguishing between a Gothic "Survival"—the vestigial products of a centuries-old medieval tradition of building—and a conscious revival of old forms beginning in the mid-eighteenth century.[4] Henry VIII's sixteenth-century break with the Roman Church had left England isolated from the artistic developments in Italy at the height of the Renaissance, and Classical motifs only began to appear alongside Gothic ones in architecture of the Elizabethan period. A true English Renaissance did not emerge until the arrival of Inigo Jones in the early seventeenth century, and by this time Continental architects had already exhausted the strict canons of the High Renaissance and reconstituted its Classical vocabulary in the more expressive grammar of the Baroque. Gothic, Renaissance, and Baroque concerns ultimately converged on London's cathedral of St. Paul's.

Old St. Paul's was a massive church in the Gothic style, but its fabric had deteriorated by the beginning of the seventeenth century. A fire in 1561 brought down the lofty spire which had once dominated the London skyline, and Inigo Jones's subsequent addition of a Classical portico on its west end (1634–40) only accentuated the decrepit antiquity of the rest of the basilica. As its days became numbered, contemporaries finally began to take notice of Old St. Paul's. In 1658, William Dugdale published *The History of St. Paul's Cathedral in London,* lavishly illustrated with engravings of the church by the Bohemian printmaker, Wenceslaus Hollar. The Great Fire of 1666 soon made the renovation of Old St. Paul's impossible, but Christopher

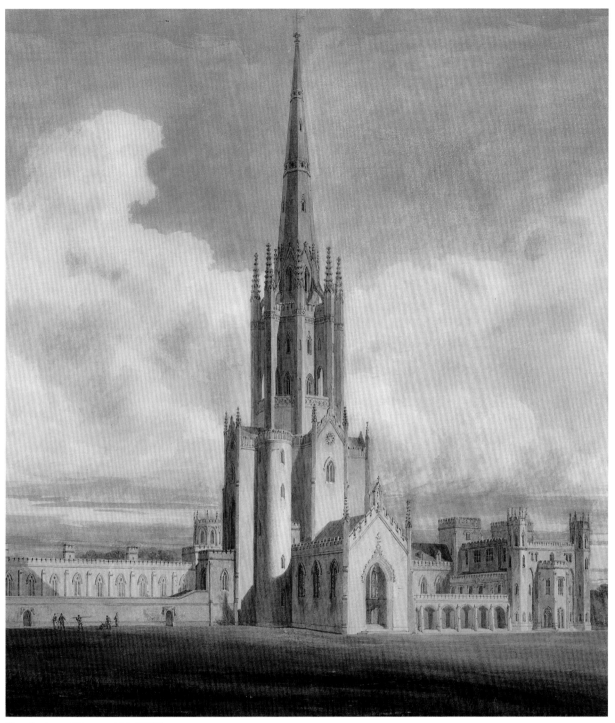

Fig. 7b. James Wyatt and J.M.W. Turner,
Projected Design for Fonthill Abbey, Wiltshire
(1798), cat. no. 9 (detail)

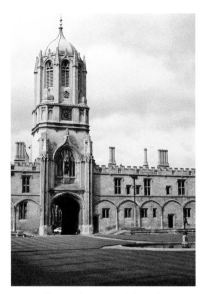

Fig. 1. Christopher Wren, Tom Tower (1681–82), Christ Church College, Oxford

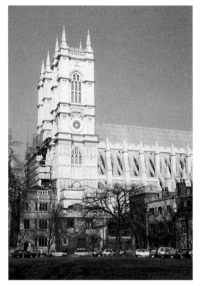

Fig. 2. Nicholas Hawksmoor, Westminster Abbey, west gable and towers (1734, completed by John James, 1744–45), London

Wren's proto-Baroque design for the new St. Paul's was by no means the demise of the Gothic style in England. Gothic was still very much in evidence in cathedral cities like Salisbury, where Wren himself supervised a renewal project at one of Britain's greatest surviving monuments of the Middle Ages. Certainly the most fertile environments for Gothic building were the medieval colleges of Oxford and Cambridge. At Oxford, Wren completed the upper stories of Christ Church College's gateway, the Tom Tower (1681–82; fig. 1), which had remained unfinished since its original foundation by Cardinal Wolsey in 1525. Though a devout Classicist, Wren clearly understood the need to strive for a unity of style in this instance. While he showed little respect for the Gothic in its own right, Wren conceded that this medieval complex would be better suited with a harmonious appearance than with an updated addition.[5]

His pupil, Nicholas Hawksmoor, arrived at much the same conclusion when confronted with the completion of the unfinished Westminster Abbey (fig. 2). Wren had earlier submitted a proposal to add towers to the façade as well as a spire at the crossing of London's most venerable medieval church.[6] As his successor, Hawksmoor first considered encasing the existing structure with an entirely new exterior, which would have replaced its genuinely medieval appearance with a distinctly eighteenth-century interpretation of Gothic.[7] Fortunately, his more modest final design (1734) added only the western gable and its two flanking towers, which were completed after his death by John James in 1744–45. Hawksmoor's reputation for fine Gothic detailing is evident in the successful unification of the older structure with his new towers, which betray their true age only in the Classical pediment above each oculus. In his earlier works as well, like All Souls College at Oxford (1716–35), Hawksmoor's facility with a delicate, personal application of Gothic ornament provides a fitting counterpoint to the Baroque conglomeration of medieval massiveness and Classical elaboration in the architecture of his occasional collaborator, John Vanbrugh.[8]

The Gothic creations of William Kent are perhaps the most representative of the early eighteenth century. Kent's Gothic remained essentially Classical in form, incorporating only superficial details like the pointed arch and quatrefoil. He made Gothic additions to Hampton Court and Westminster Hall in the 1730s,[9] but his greatest contributions came in the realm of garden design. His English gardens rejected the geometric formality of French plans in favor of a contrived wilderness, accentuated with sham ruins and eye-catching pavilions, some of which he made even more picturesque with a jagged Gothic silhouette (fig. 3, cat. no. 3).

By Kent's time, the appreciation of Gothic as a means of expression was being codified in Britain. Batty Langley's *Gothic Architecture, Improved by Rules and Proportions* (1742) was the first pattern book devoted specifically to Gothic designs, and it had a profound influence on architecture, garden planning, and interior decoration. For Langley, the Gothic represented a series of orders, as did the Doric, Ionic, and Corinthian orders of Classical architecture. But in spite of his sincere attempt to chart the style's history and endow it with a canon of rules that his Classically-minded contemporaries could appreciate, Langley's designs remained fundamentally Kentian,

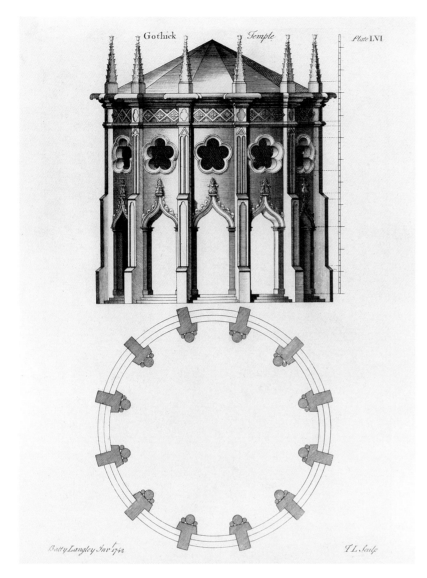

Fig. 3. William Kent, *Design for a Gothic Umbrella Temple* (ca. 1730s), cat. no. 3

Fig. 4. Batty Langley, *Design for a Gothic Garden Pavilion,* engraving, from *Gothic Architecture, Improved by Rules and Proportions* (1742), Beinecke Rare Book and Manuscript Library, Yale University

Batty Langley and William Kent

One of the earliest applications of the revived Gothic style was in garden decoration. England's eighteenth-century fascination with Claude Lorrain's pastoral landscape paintings created a garden aesthetic built around the picturesque vista of woods, water, and Classical temples or ruins. Since Roman remains were rare in Britain, a garden designer might substitute authentic medieval ruins already on the property, or he could simply build an artificial one. Gothic ruins and pavilions also provided the minute detailing and dramatic silhouettes likely to hold the viewer's attention.

Batty Langley wrote the most influential pattern book for Gothic designers of the mid-eighteenth century. His *Gothic Architecture, Improved by Rules and Proportions* (1742) was the first of its kind devoted specifically to the Gothic style. He legitimized Gothic as a proper mode for garden decoration, even if his designs remain fundamentally Classical in inspiration, and only Gothic in detail.

Among the most significant British architects of this period to experiment with Gothic designs was William Kent. A Palladian at heart, Kent, like Langley, envisioned Gothic architecture largely along Classical lines, but with a different repertory of decorative motifs. The overall form of this garden pavilion (fig. 3) follows Classical models, but Kent has outfitted it with bundled columns, pointed arches with cusped tracery, and quatrefoils set into the gables in front of a blind arcade.

13

with Gothic features resting rather uncomfortably on a Classical body (fig. 4). This would also be the outcome for the Gothic examples included in Thomas Chippendale's *The Gentleman and Cabinet-Maker's Director* (1754), which more than any other pattern book introduced Gothic details to furniture design. Ultimately, the "Gothick" devices of the early eighteenth century amounted to a stylistic mode equivalent to the Chinese or Grecian styles, which also served as foils to the prevailing Rococo trend in decoration.

Probably the first truly significant figure of the British Gothic Revival was Horace Walpole, author of the movement's first novel and builder of its first real monument. In *The Castle of Otranto* (1765),[10] Walpole established a literary genre that would reach its pinnacle at the end of the eighteenth century in the novels of Ann Radcliffe and Matthew Lewis, even influencing the next great generation of British Romantic writers, such as Wordsworth, Byron, Keats, and the Shelleys. At Strawberry Hill, Walpole renovated one of Britain's country houses to produce a mansion that was new in its "antiquity."

At first glance, Strawberry Hill appears much like its predecessors in detail: on the exterior, its use of crenellations, quatrefoils, and pointed arches is reminiscent of garden architecture derived from William Kent and Batty Langley (fig. 5, cat. no. 2). But the insistent asymmetry of the plan represents a marked departure from the more Classical regularity of earlier works. More importantly, Walpole was determined to produce an authentic form of Gothic. Rather than contenting himself with the notion of the style as it was understood in his day, he sought out specific sources for each of his decorative details. Walpole and his "Committee" of designers, chief among them Richard Bentley and John Chute, copied railings and ceiling vaults from Gothic halls and cathedrals. This "copying" was often rather freely done, resulting in a work that remains unquestionably Rococo in spirit. The ceilings, as authentic as they may have appeared, were merely plaster recreations without any of the structural foundations of true Gothic vaults. Medieval tombs became the sources for canopied chimney pieces, and the arched bookcases in the library (fig. 6) were based on the choir screen in Old St. Paul's (known from Dugdale's *History*).[11] These examples also show the limit of Walpole's concern for accuracy. While he insisted on using true Gothic models as the basis for his designs, he had no qualms about fundamentally transforming the intended function or context of his prototypes.

A certain dichotomy emerges between Walpole's literary and architectural motives. His aim at Strawberry Hill was to replace the fanciful constructions of his predecessors and contemporaries with a monument true to its medieval origins. In this respect, his study of actual Gothic buildings in search of archaeological accuracy anticipates that of later generations and of Pugin in particular. But Walpole's more immediate influence may be traced through the definition of Gothic he provides in *The Castle of Otranto*. It is this conception of the Middle Ages, characterized by the dark, often sinister atmosphere familiar to today's readers of Gothic novels and Romantic poetry, that informed the writings of William Beckford and Sir Walter Scott, and ultimately brought a Gothic sensibility into the mainstream of British consciousness by the beginning of the nineteenth century.

Strawberry Hill

Horace Walpole's Strawberry Hill is commonly considered the first major monument of the Gothic Revival. In 1749, Walpole purchased a modest country cottage on the banks of the Thames at Twickenham, near London, and spent more than three decades enlarging and renovating it in a Gothic style. Strawberry Hill caused such a sensation in its time that Walpole eventually succumbed to the public interest by opening his home on a limited basis to curious visitors. In 1760 he produced the first catalogue of the house and its treasures, making revisions over the coming years that culminated in his publication of *A Description of the Villa of Mr. Horace Walpole* (1784).

Walpole despised the fanciful Gothic designs popularized in his day by Batty Langley (see cat. no. 5 and fig. 3) and Thomas Chippendale. He demanded historical accuracy in the use of Gothic forms, and to this end he copied elements directly from existing medieval structures rather than blending them with Classical or Rococo motifs. The arched bookcases in his library, for example, were based on the choir screen in Old St. Paul's in London, known since its demolition in the seventeenth century only through the engravings in William Dugdale's *The History of St. Paul's Cathedral* (1658). The chimney piece here derived from medieval tombs in Westminster Abbey and Canterbury Cathedral.

Walpole knew that the Gothic was a more complicated system than merely a combination of pointed arches and quatrefoils, even if some level of fancy remains in his result. His application of Gothic remained superficial, with ceilings constructed entirely of plaster to give the illusion of stone vaulting, a fact that many nineteenth-century medievalists criticized for ignoring the inherently structural nature of Gothic architecture.

Sandby's view here is nearly identical to an engraved illustration in Walpole's *Description* of 1784. Walpole made Strawberry Hill's floor plan deliberately asymmetrical, in contrast to the centralized arrangements preferred in English Palladian architecture of the period. The main entrance to the house, rather than calling attention to itself as in a Classical design, is discreetly placed at the end of a recessed walkway (not visible in this view). Exterior details are also conspicuously Gothic in form, with windows in the shape of pointed arches and quatrefoils, and pinnacles and the crenellated Round Tower to provide an irregular skyline.

Fig. 5. Paul Sandby, *View of Strawberry Hill from the Southeast* (ca. 1783), cat. no. 2

Fig. 6. John Carter, *The Library at Strawberry Hill*, watercolor, from *A Description of the Villa of Mr. Horace Walpole*, Richard Bull's extra-illustrated copy, p. 102 (1788), Lewis Walpole Library, Yale University

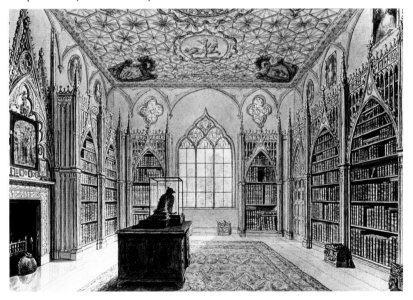

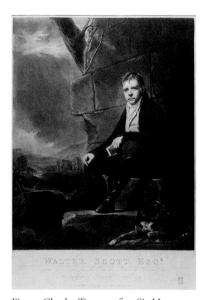

Fig. 9. Charles Turner, after Sir Henry Raeburn, *Portrait of Sir Walter Scott* (1810), cat. no. 84

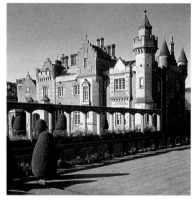

Fig. 10. Sir Walter Scott, Robert Atkinson, and others, Abbotsford (1812–32), Melrose, Roxburghshire, Scotland

Romantic Visions of the Past

Like Walpole, William Beckford authored an influential Gothic novel, *Vathek* (1786), and also like Walpole, he chose to live in an extravagant Gothic palace. But if Strawberry Hill had been a relatively quaint exercise in appreciation—a "gothic mousetrap"[12]—Beckford's majestic Fonthill Abbey showed the Gothic Revival at its peak of excess (figs. 7a, 7b, & 8, cat. no. 9). Beckford commissioned James Wyatt in the 1790s to design for him an appropriately Romantic ruined abbey on his rural Wiltshire property. Wyatt, whose earlier credits included Lee Priory in Kent (1782–90), was the leading Gothic practitioner of the day.[13] A grandiose cruciform structure that culminated in an octagonal lantern spire derived from the cathedral of Ely, Fonthill challenged the engineering limits of its time. After a series of design changes, the first tower that was erected collapsed beneath its own weight in 1800. Beckford had the tower rebuilt and took up residence at Fonthill by 1807. The publication in 1823 of John Rutter's *Delineations of Fonthill and Its Abbey* (fig. 8) lured tourists to Wiltshire with its descriptions and picturesque illustrations of this modern homage to the past, but by this time Beckford's gigantic folly had bankrupted him, forcing him to sell the estate and move to simpler lodgings in Bath that year. Not long after Beckford had vacated Fonthill, a storm in 1825 brought down the tower yet again, leaving the mansion in ruins.

Following the models set forth by Walpole and Beckford, the early Gothic novel reached the height of its popularity around the turn of the nineteenth century. This literary genre developed out of the melancholic tradition of Thomas Gray and the "Graveyard Poets" of the eighteenth century,[14] and ultimately descended from Milton, Spenser, Marlowe, and Shakespeare. The somber, often terrifying, mood of the Gothic mode came from an association with the largely unknown history of the Middle Ages. Out of this mysterious past came a mythical notion of medieval times, one consciously constructed to oppose the rationalist tendencies of the Enlightenment. It was works like Matthew Lewis's scandalous *The Monk* (1796) and Ann Radcliffe's immensely popular *The Mysteries of Udolpho* (1794) that Jane Austen lampooned in *Northanger Abbey* (1818). But no writer caught the imagination of the age as fully as Sir Walter Scott (fig. 9, cat. no. 84). His "Waverley novels," a series of medieval romances including *Ivanhoe* (1819), seemed to contain an authentic historicity absent from the more fanciful settings of earlier Gothic novels. These works brought a fascination not only with the mythology of the Middle Ages, but also with the details of Gothic architecture, to a broad spectrum of English readers. Only the Bible and Shakespeare inspired more British paintings than Scott's tales, and by mid-century a towering Gothic memorial to the author had been built along Princes Street in Edinburgh.[15] Whereas Strawberry Hill and Fonthill had remained curiosities in their time, Scott's Gothic home in Scotland, Abbotsford (1812–32; fig. 10), inspired many well-to-do Englishmen to construct their own domestic castles.

One of the most important features of any Gothic story was its setting, usually away from the city and amid ruinous churches or castles. The association of Gothic structures with a rural environment went back to the early eighteenth century, when castellated pavilions had been standard ele-

Fonthill Abbey

William Beckford's extravagant Wiltshire home is one of the key monuments of the Gothic Revival. Beckford first engaged James Wyatt in 1791 to design a sham ruin, but since the architect was already committed to renovations at Windsor Castle, construction did not begin until 1796. The grandiose "abbey and palace" of Fonthill, originally intended only as a picturesque spot to entertain picnicking guests, culminated in a soaring tower at the summit of its octagonal central hall. Wyatt produced this early watercolor design for the structure (figs. 7a & 7b [p. 11]) and exhibited it at the Royal Academy in 1798. The painting's execution is largely the work of Wyatt's assistant, the young Joseph Mallord William Turner, who would go on to become the greatest British landscapist of the nineteenth century and the collector Beckford's favorite painter. Here, Wyatt proposes a heavily buttressed central tower to support a sweeping vertical spire, not unlike that of nearby Salisbury Cathedral. In its final form, Fonthill's tower would lose the pointed spire and much of the structural buttressing, which along with the use of

unsuitable materials led to its instability and partial collapse in 1800.

Undaunted, Beckford was intent not only to rebuild, but to make Fonthill his permanent residence. He was able to move into his new home in 1807, although construction continued until shortly after Wyatt's death in 1813. A high wall enclosing the estate kept visitors from seeing Fonthill for a decade, adding to the mystique of what had already become one of England's most famous buildings. But after having lavished a fortune on his gigantic folly, Beckford found himself badly in debt, and made plans to sell Fonthill and all of its furnishings at auction in 1822. The house was opened to the public for a preview, allowing most of the curious their first glimpse of Beckford's home. A slew of illustrated publications followed, making Fonthill visible to the masses for the first time, but only John Rutter's *Delineations of Fonthill and Its Abbey* (1823) had the cooperation of Beckford himself. Beckford found a buyer and spent his remaining years in slightly more modest accommodations in Bath. Only two years later, in 1825, Fonthill's tower collapsed again, destroying practically the entire structure.

Fig. 8. John Rutter, *Fonthill Abbey,* engraving, from *Delineations of Fonthill and Its Abbey* (1823)

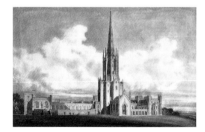

Fig. 7a. James Wyatt and J.M.W. Turner, *Projected Design for Fonthill Abbey, Wiltshire* (1798), cat. no. 9

ments in English gardens. Even sham ruins were incorporated into their designs, but with the rise of the Romantic movement, these intentionally dilapidated devices became charged with more than merely a picturesque significance (fig. 11). Ruins underscored the ultimate transience of all human civilization in the face of nature's omnipotence. Even at the height of the Enlightenment, Jean-Jacques Rousseau had demonstrated a proto-Romantic delight in nature, and Edmund Burke's *A Philosophical Enquiry into the Origin of our Ideas of the Sublime and Beautiful* (1757) extolled the majesty of nature's irrational forces. The fact that decaying Gothic structures were visible throughout the English countryside (fig. 12, cat. no. 4) provides only a partial explanation of the style's association with ruins; its asymmetry seemed less artificial (although many times it was) and its religious connotations especially appealed to Romanticism's evocation of an earlier, simpler time.

As much as the Romantics praised the irrationality they associated with nature and the past, they could not prevent Enlightenment thought from creeping into contemporary discussions of Gothic. Walpole had been the harbinger of a more systematic approach to the study of its history, a movement which gained momentum in the early decades of the nineteenth century. Amateur antiquarians were joined by medieval archaeologists in their firsthand investigations of monuments, which they described, sketched, researched, and finally published, making accurate Gothic detailing more widely available. This fury of activity culminated in Thomas Rickman's enormously influential study, *An Attempt to Discriminate the Styles of English Architecture, from the Conquest to the Reformation* (1817), the source of the stylistic terms—Norman, Early English, Decorated, and Perpendicular—still used in any discussion of medieval English architecture.[16]

With this new understanding of medieval architecture, the restoration of old buildings—which had been a matter of course in Wren's time, if only because the structures in question were often in danger of imminent collapse—now excited cries of disapproval from critics who felt that the restorers had gone too far. The chief problem with this new generation of restorers was that, convinced that they now knew the true nature and history of medieval architecture, they felt it perfectly within reason not only to restore or even renovate, but to correct and complete what they perceived to be a building's flaws and omissions. Gothic purists were quick to comment on the failure of a modern addition or the horror of a decision to remove an "incorrect" element. One of the first, and certainly the most savage, of these attacks was leveled against James Wyatt ("the Destroyer," as Pugin would later call him) for his reputedly overzealous restoration of Salisbury Cathedral. In the nineteenth century, the reputation of George Gilbert Scott might have fared somewhat better had he not agreed to restore far more cathedrals than he could possibly have done with the diligence and caution they demanded.

Medieval buildings that had not fallen into disrepair often underwent dramatic renovations in subsequent centuries. The most important of England's castles, Windsor, had remained a royal residence long after its battlements had ceased to play a defensive role, and frequent alterations had given it as much a Classical appearance as a medieval one. The task of return-

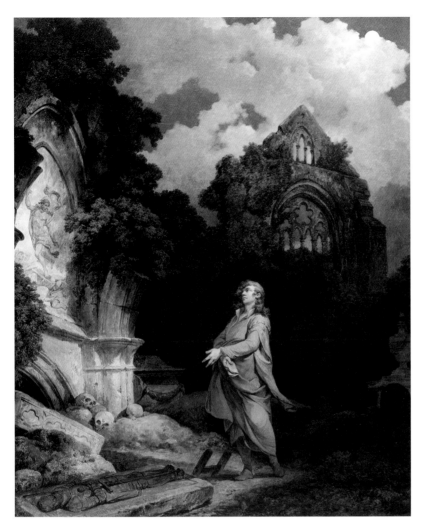

Fig. 11. Philip James de Loutherbourg, *Philosopher in a Moonlit Churchyard* (1790), Yale Center for British Art, Paul Mellon Collection

Fig. 12. John Wootton, *Riders Pausing by the Ruins of Riveaulx Abbey* (ca. 1740–50), cat. no. 4

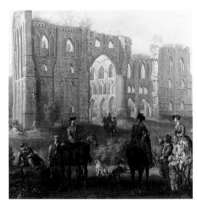

John Wootton
Riders Pausing by the Ruins of Rievaulx Abbey (ca. 1740–50)
A celebrated painter of animals and sporting scenes, John Wootton here illustrates an early stage in the appreciation of medieval ruins. Pausing before the remains of Rievaulx, one of the first Cistercian abbeys to be founded in England, a group of upper-class riders gazes upon the monument with interest. Although Gothic had for centuries remained most vital in the parish churches of rural England, the renewed study in medieval antiquities came about only when they began to attract the attention of wealthy, educated gentlemen like Horace Walpole.

Philip James de Loutherbourg
Philosopher in a Moonlit Churchyard (1790)

A veritable manifesto of the Romantic spirit, De Loutherbourg's painting contains all of the elements that united Romanticism and the Gothic in opposition to Enlightenment Neoclassicism. The darkness of night and isolation of the forest setting establish an eerie tone here for profound reflection. A lone philosopher stands in contemplation upon holy ground, witness to a divine image from the past. The transcendence of Christ's Resurrection, visualized in the painting at the left, provides hope for the dead whose bones lie below. This poignant reminder of the inevitability of death—*memento mori*—is reiterated in the crumbling medieval church, which nature is slowly reclaiming. Such formulas were popular among painters in the years around 1800. Perhaps the greatest practitioner in the churchyard genre was the German Romantic, Caspar David Friedrich, whose works have much in common with this composition.

De Loutherbourg began his painting career in the Salons of Paris in the 1760s, but after moving to London he earned prominence as well in theatrical design. William Beckford even engaged him in 1781 to design an elaborate setting for a Christmas party, a telling harbinger of Beckford's later dramatic sensibility at Fonthill (cat. no. 9). The painter was fascinated with the conjunction of aesthetics, spirituality, and nature in the doctrine of the Sublime, eventually falling under the spell of a Swiss mystic in 1786 and publishing a pamphlet on faith-healing in 1789.

ing Windsor Castle to a more unified medieval appearance fell to the architect who with Fonthill had established himself as Britain's leading Gothicist, James Wyatt. After Wyatt's death, the remodelling was carried out by his nephew, Jeffry Wyatville, to whom most of Windsor's present appearance may be attributed (cat. nos. 7 & 8; fig. 13). Wyatville doubled the height of the squat Round Tower and added crenellations, lending a more picturesque silhouette to the castle as a whole. Most of the structures encircling the Upper Ward also belong to Wyatville's design: while their ornament blends harmoniously with the castle's true medieval portions, the profusion of windows sets them apart as a product of the modern age.

The connection between castles, monarchs, and the Middle Ages was an obvious one to adopt at Windsor. But when in 1834 the old Palace of Westminster was consumed by fire, there was no precedent for the type of design most appropriate to the modern seat of government. If anything, a democratic system might have sought its models in ancient Athens; to be certain, Classicism had long been the style of choice for monumental public buildings.[17] So the official pronouncement in 1835 that the new Houses of Parliament were to be Gothic or Elizabethan in style raised more than a few eyebrows. Partly, this decision had a practical rationale: ancient Westminster Hall, the only substantial portion of the old complex spared from the flames, needed to be integrated sympathetically into the new structure. A medieval Parliament building may also have seemed fitting for the heirs to the thirteenth-century Magna Carta. But the role of nationalism in this choice was certainly the most important, overriding an otherwise entrenched stylistic bias in favor of Classicism. The Classical tradition was fundamentally a Mediterranean one, revived by the Italians of the Renaissance who lived amidst the ruins of Rome and Greece. Apart from Bath and Hadrian's Wall, Britain's architectural antiquity was dominated instead by the remains of obsolete fortresses and religious establishments suppressed under Henry VIII.[18]

The commission to rebuild the Houses of Parliament was awarded to Charles Barry, whose design was selected from a field of ninety-seven competition entries (cat. no. 41; fig. 14). Barry had enlisted the expertise of Augustus Welby Northmore Pugin, Britain's most staunch advocate of Gothic, to produce a series of presentation drawings for the competition, and he would turn to Pugin again a decade later to design the building's elaborate interiors.[19] Barry's choice of style was Tudor, a distinctively English form of late Gothic that had the added benefit of complementing the adjacent Chapel of Henry VII at the east end of Westminster Abbey. Quotations from earlier Gothic Revival buildings are evident in Barry's design: the octagonal central lobby, with radiating halls and capped by a spire, recalls the cruciform plan of Wyatt's Fonthill; and the Big Ben tower itself derives from Pugin's design for Scarisbrick Hall in Lancashire (1837–45).[20] But while it may appear essentially Tudor on the surface, the principles underlying Barry's plan are undeniably Classical. Aside from the dissimilarity of the Victoria and Big Ben towers at either end of the building, and the accommodations made to incorporate the slightly askew Westminster Hall complex, Barry's floor plan is exceptionally regular. This is most apparent in the expansive river façade, symmetrically constructed of evenly spaced, gener-

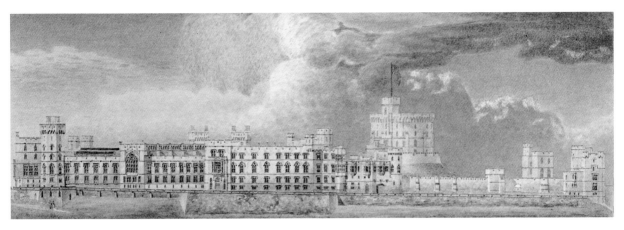

Windsor Castle

The most grand of Britain's royal residences, Windsor owes much of its present appearance to the nineteenth-century restorations directed by Jeffry Wyatville. Under George III, James Wyatt had added Gothic windows to begin to bring some order to a complex that had grown haphazardly over the centuries. In 1824, George IV commissioned Wyatt's nephew, Jeffry Wyatt (who immediately changed his name to the more medieval-sounding Wyatville), to complete the task of returning the castle to a more unified medieval appearance. Wyatville modernized Windsor's obsolete defensive features, adding the upper half of the Round Tower to give the castle a dramatic focal point, and using crenellations purely for picturesque decoration. Around the Upper Ward, he breached the old curtain walls with more palatial windows and built the new George IV Gateway as the castle's primary entrance to the south. Wyatville also remodelled the Royal Apartments in the Gothic fashion, stripping away most of the Restoration interiors designed by Hugh May for Charles II. While still in his father's employ, the teenaged Augustus Welby Northmore Pugin contributed some of the furniture designs, although he would later renounce his youthful work at Windsor as fanciful.

These views (cat. nos. 7 & 8, fig. 13) are studio renditions of the presentation drawings (still in the Royal Collection at Windsor) with which Wyatville secured the commission from George IV, who had solicited designs from John Nash, John Soane, and the other leading British architects of the day.

Fig. 13. Jeffry Wyatville, studio, *Windsor Castle, North Elevation* (ca. 1830), cat. no. 8

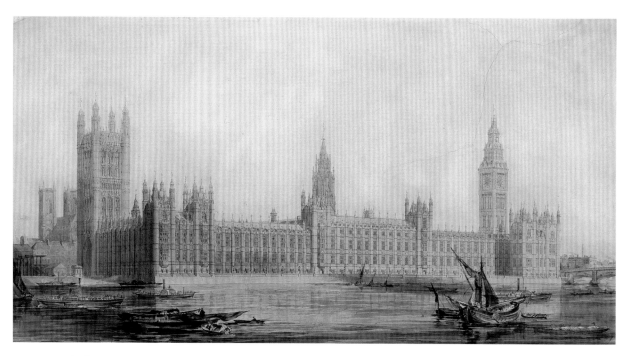

Fig. 14. Sir Charles Barry, *Perspective View of the New Houses of Parliament* (ca. 1840s), cat. no. 41

Houses of Parliament

As the seat of British power in London, the royal palace of Whitehall and Parliament's adjoining complex at Westminster had been lamentably disorganized for centuries. Inaction towards the problem finally yielded in 1834, when a fire levelled practically all of Westminster's waterfront. The competition to rebuild the Houses of Parliament specified a Gothic or Elizabethan design, a decision that startled most of England's Classically-inclined architects.

Charles Barry received the commission with his entry in the Tudor style of the sixteenth century. This later drawing shows the design close to its final form; only the silhouettes of the three towers were to undergo subsequent changes. The underlying Classicism in Barry's design is evident in the riverfront elevation, with its regularly-spaced bays and symmetrically-placed towers. To assist with the Gothic detail and interior decoration, Barry enlisted England's leading Gothic expert, Augustus Welby Northmore Pugin, whose work is most apparent in the outfitting of the House of Lords.

The sheer scale of Barry's Houses of Parliament meant that its direct influence on later projects would be limited. A few other nations seized upon the idea of Gothic when it came to designing their own Parliament buildings in the nineteenth and early twentieth centuries, most spectacularly in Budapest, Hungary, and Ottawa, Canada.

ously fenestrated bays. As the Gothic purist Pugin was to describe it to a friend: "All Grecian, Sir; Tudor details on a classic body."[21]

Britain was not alone in claiming Gothic as the symbol of an ancient national identity. By the turn of the nineteenth century, other parts of northern Europe were viewing the style as inherently their own. Each national school of Gothic had its own peculiarities, making the style in essence a vernacular form in comparison to the universal application of the Classical language throughout Europe. Goethe was among the earliest proponents of Gothic as a distinctly German mode, one forged by the Germanic peoples who had stood outside the borders of the ancient Roman Empire. During the course of the nineteenth century, German builders finally brought the massive, unfinished cathedral of Cologne to completion (1880), while in Bavaria, largely under the influence of Wagnerian epic romances, "Mad" King Ludwig II took up residence in his fanciful new alpine fortress of Neuschwanstein. France certainly had a stronger case as the historical originator of Gothic, and a new appreciation for the style developed out of the Romantic writings of Victor Hugo, especially his *Notre-Dame de Paris* (1831). Eugène-Emmanuel Viollet-le-Duc assumed the leading role of interpreting the past in his restoration of Paris's cathedral in the mid-nineteenth century, which aroused the sort of controversy among the French that Wyatt's and Scott's did in Britain.

Victorian Christendom

The profusion of new Gothic buildings in nineteenth-century Britain not only reflected a prevailing cultural trend; there were more immediate societal factors in its expanding popularity. A primary consequence of the industrialization of England had been the rapid migration of its population into the cities. This new redistribution of the work force had transformed rural farmers into urban laborers on such a large scale that established institutions had difficulty keeping pace with the changes. In the Anglican Church, rural congregations dwindled or disappeared entirely as pre-existing urban churches struggled to accommodate the influx of new parishioners. Parliament's solution to this problem was the Church Building Act of 1818, establishing a fund under which more than 200 new churches were constructed during the next two decades. About eighty percent of these "Commissioners' churches" were Gothic in design, although this statistic testifies less to a deliberate aesthetic preference than to the relative speed and economy with which a masonry church with modest Gothic detailing could be built, as compared to the expense of outfitting a structure with the marble porticoes required of the Classical orders.[22] Needless to say, the Church Building Act produced few works of any real architectural merit.[23]

The Romantic movement had begun to associate definite meanings with the Gothic, a style which in the eighteenth century had contained primarily visual interest. But the Romantics continued to view it as inherently irrational, and therefore hardly amenable to such strict canons of design as had been applied to Classicism since the Renaissance. The cause of providing the Gothic with a system of rules was finally taken up in the 1830s and 1840s by several groups of religious reformers who, disillusioned with the

state of Christianity in their day, looked to the great cathedrals of the Middle Ages as the most appropriate models for correct worship. These revivals gave Gothic more than merely a historical or conventional meaning: they invested the style with a moral authority as well.

The Gothic university cities of Oxford and Cambridge were to produce the two most important ecclesiastical reform movements. The first of these, the Oxford Movement, consisted of scholars and theologians who sought to bring some of the old richness back into the liturgy of the Anglican Church. Members of the Oxford Movement—known as Tractarians for publishing a series of pamphlets entitled *Tracts for the Times*—found contemporary church ritual stale, and they looked back to the time before the Puritan Commonwealth of Oliver Cromwell, and even back to the Middle Ages themselves. Choosing models from medieval Roman Catholicism rather than Anglicanism itself caused many of the Tractarians to be branded as papists, and indeed some of them ultimately converted to the Catholic faith. The Tractarians espoused "High Church" or "Anglo-Catholic" doctrines, placing greater emphasis on the celebration of ritual in general, the Sacrament of the Eucharist in particular, and the renewed use of symbolism in the Anglican Church. High Church congregations again directed their attention towards the altar, whereas the more Calvinist "Low Church" form of Anglicanism remained focused on sermons delivered from the pulpit.

As such, the Oxford Movement's promotion of ritualism had important consequences for church architecture. In 1839, a group of Cambridge students formed the Cambridge Camden Society, ostensibly an antiquarian club interested in the old churches of England. However, its own members' support for the Tractarians made the Camden Society a complementary social force to the Oxford Movement. Scholars have called the Camdenians "probably the most influential undergraduate society of all time,"[24] and their journal, *The Ecclesiologist*, which first appeared in 1841, "one of the most important English architectural periodicals."[25] Through *The Ecclesiologist* and other pamphlets, the Camden Society (from 1846 known as the Ecclesiological Society) instructed architects and clergy on the most important features of the modern Anglican church. Since their antiquarian studies had exposed the Camdenians mainly to medieval buildings of Britain's Catholic past, and their sympathies for the Oxford Movement meant an emphasis on ritual and symbolism, they too were forced to defend themselves from charges of popery. Nevertheless, their influence shaped the church designs of the Victorian era, which had to return to more medieval layouts if they were to accommodate a pre-Reformation liturgy.

In 1836, five years before the first issue of *The Ecclesiologist*, a book appeared bearing the provocative title, *Contrasts, or, A Parallel Between the Noble Edifices of the Fourteenth and Fifteenth Centuries, and Similar Buildings of the Present Day; Shewing the Present Decay of Taste.* Its twenty-four-year-old author, Augustus Welby Northmore Pugin, was to become arguably the single most important figure in the Gothic Revival. His father, Augustus Charles Pugin, had himself played a significant role in the study of medieval buildings. Having emigrated from France during the Revolution, the elder Pugin worked as a draughtsman with John Nash, one of England's leading

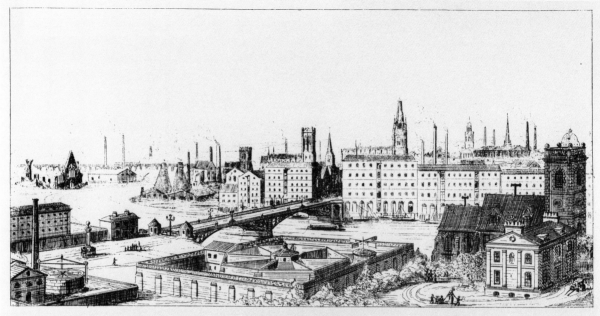

THE SAME TOWN IN 1840

1. St Michaels Tower, rebuilt in 1750. 2. New Parsonage House & Pleasure Grounds, 3. The New Jail, 4. Gas Works, 5. Lunatic Asylum, 6. Iron Works & Ruins of St Maries Abbey, 7. Mt Evans Chapel, 8. Baptist Chapel, 9. Unitarian Chapel, 10. New Church, 11. New Town Hall & Concert Room, 12. Westleyan Centenary Chapel, 13. New Christian Society, 14. Quakers Meeting, 15. Socialist Hall of Science.

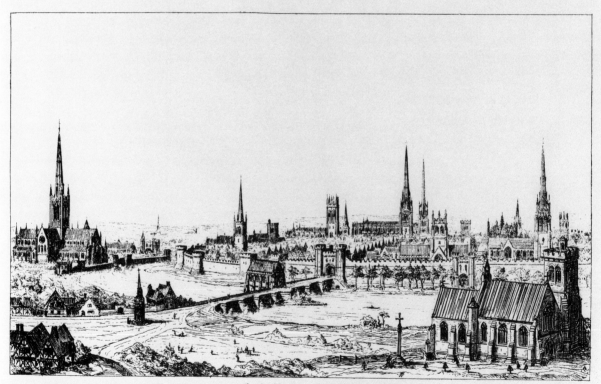

Catholic town in 1440.

1. St Michaels on the Hill, 2. Queens Crofs, 3. St Thomas's Chapel, 4. St Maries Abbey, 5. All Saints, 6. St Johns, 7. St Peters, 8. St Alkmunds, 9. St Maries, 10. St Edmunds, 11. Grey Friars, 12. St Cuthberts, 13. Guild hall, 14. Trinity, 15. St Olaves, 16. St Botolphs.

Fig. 15. A.W.N. Pugin, "Catholic town in
1440; The same town in 1840," from *Contrasts*
(1836), plate 193, Stephen Parks Collection

25

Fig. 18. A.W.N. Pugin, St. Giles Church, Cheadles (plan 1842, consecrated 1846)

architects. He specialized in detailed drawings taken from firsthand observation of existing Gothic buildings, which he compiled into a series of illustrated volumes, including *Specimens of Gothic Architecture* (1821–23). A similar insistence on accuracy of detail would remain with the younger Pugin throughout his brief career, reviving the underlying objectives set forth at Walpole's Strawberry Hill, and abandoning the more contrived motives of Romanticism.

The controversy that erupted around the publication of *Contrasts* made Pugin an instant sensation. *Contrasts* presents paired illustrations of authentic medieval buildings and their modern-day counterparts in an attempt to demonstrate Pugin's fervent conviction that society had experienced a precipitous decline since the late Middle Ages. In perhaps the best-known plate from this book, Pugin shows us a town as he imagines it would have looked in 1440 and compares that to its likely appearance in 1840 (fig. 15). A quaint city of church spires, tangible symbols of the unquestioning faith of the Middle Ages, has been usurped by the polluted industrial metropolis of the present. Gothic details have been suppressed or replaced by Classical ones. Many churches have been demolished, and the truncated towers of those that remain can barely compete with the smokestacks that now pierce the horizon. Most menacing of all is the large prison complex that fills the foreground where once the city's medieval residents could enjoy the open land.[26] This was no subtle piece of propaganda.

But Pugin's critiques of contemporary society, religion, and architecture went much further. To him, Gothic was not merely the best style for churches: it was the only appropriate one. This belief is the cornerstone of what later historians have termed the "ethical" trend in Gothic Revival art and architecture.[27] Ecclesiastical designs dating to the twelfth through fifteenth centuries came to be considered by Pugin and his adherents as the most worthy models to emulate, since they represented the age of the Church's greatest sovereignty in Europe. Sixteenth-century works became suspect not only because of the intrusion of pagan Classical motifs, but also for their possible associations with the Protestant Reformation. Pugin himself had converted to Roman Catholicism in 1835, a year before publishing *Contrasts*, and in large part his religious belief shaped his subsequent writings and creations.

Although Pugin's own rhetoric had spurred on a Catholic revival to accompany the High Church Anglican movement begun at Oxford and Cambridge, his religious conversion nevertheless made the task of finding patrons for his work a difficult one. While Pugin designed the Roman Catholic cathedrals of Southwark and Birmingham, few Catholic parishes could afford more than a modest church (see cat. nos. 59 & 60, figs. 16 & 17). He was fortunate to find an ally in the sixteenth Earl of Shrewsbury, who in 1840 commissioned from Pugin one of the architect's finest churches, St. Giles, Cheadle, Staffordshire (fig. 18). Aside from the delicate tracery of its windows and the sweeping verticality of its single western spire, there is little obvious adornment on the exterior of this modest stone church. Inside, Pugin's decoration explodes in a Catholic sumptuousness unfamiliar to England for centuries. Pillars and walls are painted with geometric patterns and figurative murals; sculptures and well-appointed altars abound. At the

Dudley Church
A.W.N. Pugin,
Exterior and interior designs for SS. Mary and Thomas of Canterbury, Dudley, Worcestershire (1838)

This preliminary design for the church at Dudley introduces unusually Germanic proportions in its exterior elevation, as Pugin commonly preferred a distinctly English appearance. As it would eventually be built in 1838–40, the church was considerably squatter. Its interior is entirely characteristic of Pugin's churches, with a decorative program culminating at the high altar. It was said that Pugin often "starved the roof to gild the altar," and his open timberwork rafters here allowed him to redirect the expense of stone vaults to the task of furnishing the interior. In *The Present State of Ecclesiastical Architecture in England* (1843), Pugin expresses some satisfaction with the modest cost of not only constructing this church, but also outfitting it with a well-stocked vestry full of liturgical objects.

Pugin's figures are not merely an indication of scale: they enact Catholic ritual before the altar and serve as exemplars for the proper use of this house of worship. The nave's floor is deliberately left vacant of seating, a feature in which Pugin again anticipated later developments in church planning. Over the centuries, elaborate pews had become status symbols for the wealthy élite whose families could afford to purchase them. In the 1840s, the Ecclesiologists of the Cambridge Camden Society published a study on the history of pews that decried current practices and urged a return to church architecture of a time before preferential seating could be bought.

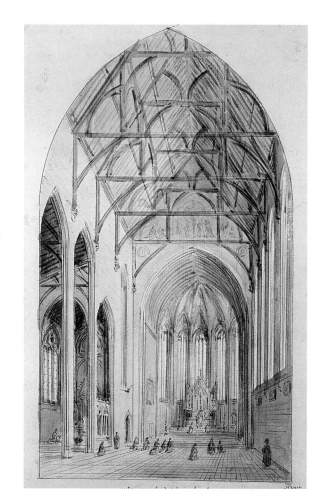

Fig. 16. A.W.N. Pugin, *Interior Design, Dudley Church* (1838), cat. no. 60

Fig. 17. A.W.N. Pugin, *Exterior Design, Dudley Church* (1838), cat. no. 59

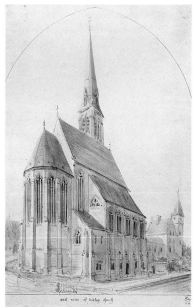

entrance to the chancel, Pugin constructed a choir screen to obscure the congregation's view of the high altar, returning an element of divine mystery to the priest's sacred act of Transubstantiation.

Pugin was passionate in his work as in his faith. Among his later writings, *The True Principles of Pointed or Christian Architecture* (1841) contains the most important exposition of his architectural beliefs. *The Glossary of Ecclesiastical Ornament and Costume* (1844) provided the modern clergyman with all the necessary information to outfit a Gothic church with complementary furnishings. His illustrations for this encyclopedic volume came from his extensive travels, during which he sketched practically every Gothic object he came across (fig. 19). He left behind hundreds of drawings of ornaments as well as buildings, all entirely from his own hand, because he could not stand the thought of entrusting his designs to an assistant. "[A] clerk, I never employ one," he is reported to have said, "I should kill him in a week." He also built himself two appropriately medieval homes, one of which included a complete abbey church, St. Augustine at Ramsgate in Kent, constructed entirely at his own expense.

The intense fervor with which Pugin lived his life apparently took its toll, as he died at the age of forty. Shortly before his death in 1852, Pugin was assigned the decoration of the Medieval Court at the Crystal Palace, intended as a showcase of Gothic Revival furnishings at the Great Exhibition of 1851. His designs were realized by his four major artisan-collaborators: encaustic tiles and other ceramics by Herbert Minton (see cat. nos. 28, 32, 33); textiles, wallpaper (compare cat. no. 30), and furniture by John Gregory Crace; metalwork and stained glass by John Hardman; and monumental church fittings and sculptures by George Myers. Among earlier events, only the decision to build the new Houses of Parliament in a Gothic style had been as important for legitimating the movement. Here at the Crystal Palace, Pugin's Gothic stood alongside the monuments of the new Iron Age: the railroad, the commercial products of England's industrial cities,[29] and Joseph Paxton's revolutionary iron-and-glass exhibition hall itself.[30]

Sharing many of Pugin's attitudes towards design without the same underlying moral conviction, George Gilbert Scott has been considered the most characteristic figure of the entire movement.[31] Scott quickly earned an international reputation in 1845 with his winning competition design for the Nikolaikirche in Hamburg, Germany, which bears more than a passing resemblance to Pugin's St. Giles at Cheadle, albeit on a much larger scale with more elaborate exterior ornamentation. On the other hand, Scott's most famous monument is hardly the type of design that Pugin would have praised. The Albert Memorial (figs. 20a & 20b), erected in London's Hyde Park in 1864–72 to commemorate the recently deceased Prince Consort, demonstrates the problems faced by an architect in adapting the Gothic style, which by mid-century had come to be associated with church architecture, to secular structures.[32] Based on a Gothic ciborium or altar canopy, the Albert Memorial removes an essentially ecclesiastical form from its intended context. Its medieval sources combine with the more Classical elements of its seated sculpture of Prince Albert and the low-relief frieze at its base to produce an ensemble that is fundamentally as distant from Pugin's vision as the patterns of Batty Langley had been.

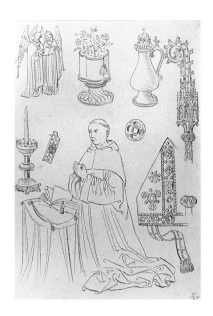

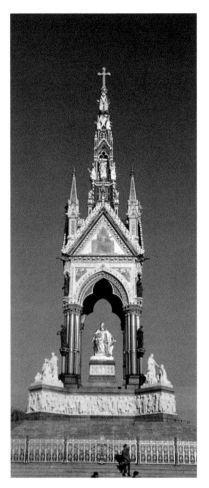

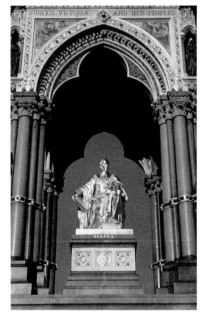

Fig. 19. A.W.N. Pugin, *Sketches after the Diptych of Christiaan de Hondt, by the Master of Bruges 1499* (ca. 1842?), cat. no. 76

Figs. 20a & 20b. George Gilbert Scott, The Albert Memorial (1864–72), London

Documenting Medieval Objects

Pugin made frequent trips to the Continent throughout his life to collect source material for his Gothic buildings and furnishings. Belgium was a convenient stop, and in several visits he was able to complement his architectural studies with an investigation of the medieval objects documented in early Netherlandish religious paintings. He made a series of drawings from the pictures held by one of Europe's leading public galleries of the time, Antwerp's Royal Museum of Fine Arts, which was permanently enriched in 1841 with the Ertborn Bequest of Old Master paintings. Eight sheets of sketches after these paintings are among the Pugin drawings recently acquired by the Beinecke Rare Book and Manuscript Library at Yale.

The sheet displayed includes a number of objects copied from a small devotional diptych in the Antwerp museum painted by an unidentified Flemish master in 1499. Pugin records details of costume (the robes of the two angels and the kneeling abbot, the miter and crozier) and ornament (candlestick, planter, and pitcher) in his quest for authenticity in his own Gothic designs. He used such models when providing engravings to illustrate his *Glossary of Ecclesiastical Ornament and Costume* in 1844. The form of the candlestick he copied from the Master of 1499's painting probably contributed to his discussion of candlesticks in the *Glossary*, undoubtedly an inspiration for the nineteenth-century maker of the ecclesiastical candlestick exhibited here (cat. no. 80).

A pupil of Scott in the 1840s, George Edmund Street became a leading architect of the High Victorian Gothic Revival. Like Pugin, he also designed the church furnishings and liturgical objects that would adorn his churches (cat. no. 79; fig. 21), and in 1856 he was appointed official designer of church plate for the Ecclesiological Society.[33] Street's work belongs to a slightly later phase in the Gothic Revival, one which wears the label "Victorian" more readily than the buildings of Pugin. Although French and German sources had crept into earlier designs, native English Gothic and Tudor influences still predominated. By the 1850s, architects were seeking out inspiration from more diverse national and regional schools.[34] Street himself published a study of Spanish Gothic architecture,[35] but even more powerful for his generation was the lure of Italy. Rather than recycling the Classical vocabulary that had for centuries defined Italy's artistic heritage, the Victorians delighted in the less appreciated peculiarities of Italian Gothic. The most recognizable visual manifestation of this new emphasis was a predilection for multicolored compositions in stone, an Italian trait illustrated most characteristically in Lombardy and the Veneto. Street's own essay, *Brick and Marble in the Middle Ages: Notes of a Tour in the North of Italy* (1855), is certainly not the first to address this burgeoning taste, but it does reflect the new direction in architecture at the middle of the century.

Perhaps no monument better illustrates the conjunction of British and Italian concerns than William Butterfield's All Saints Church, Margaret Street, London (1849–59; fig. 22). Unlike Pugin, whose colorfully appointed interiors remained hidden behind a somber, grey façade, Butterfield built variegated coloring into the structure of the church itself. This "constructional polychromy"—horizontal bands and geometric patterns of black brick on a red fabric—made the exterior as lively a canvas as the ornate interior. All Saints served as the model church of the Ecclesiological Society in London, which had begun to promote the use of polychromy in *The Ecclesiologist* during the late 1840s.[36]

The role of polychromy in architecture, as well as its Italian influences, invariably implicates one of the giants of nineteenth-century art theory, John Ruskin. Although he chose to distance himself somewhat from the mainstream of the revival, his writings were more responsible than any others for fueling the mania for Gothic in the later Victorian period. Ruskin's first architectural study, *The Seven Lamps of Architecture* (1849), lays out an aesthetic system using much the same terminology as the Classically-inclined art critics of the eighteenth century, but he reaches a very different conclusion in his unreserved praise for the Gothic style. His particular admiration for the Gothic buildings of northern Italy is even more evident in *The Stones of Venice* (1851–53), in which he advances his theories most potently in the famous chapter on "The Nature of Gothic." Not all of his critiques are terribly original; he reiterates ideas from Pugin's writings and promotes features already known from Butterfield's architecture. But by framing the virtues of Gothic in the established language of aesthetics, Ruskin's writings gave license to every Victorian architect to adopt a style that was long considered too ecclesiastical or simply inferior to Classicism. Ruskin himself had little enthusiasm for most creations of the Gothic Revival, including

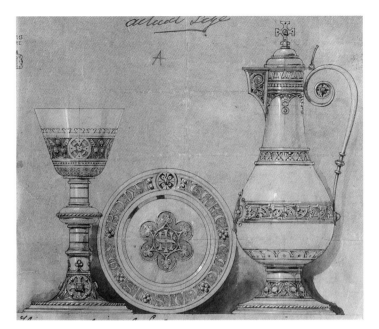

Fig. 21. George Edmund Street, *Design for a Communion Set* (ca. 1850), cat. no. 79

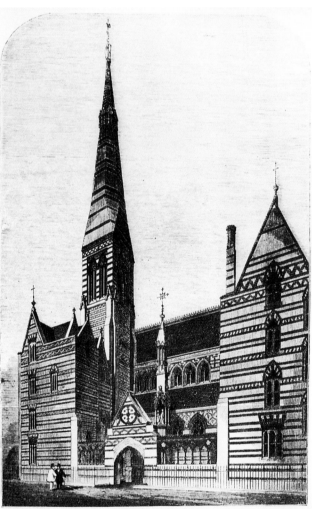

Fig. 22. William Butterfield, All Saints Church (1849–59), Margaret Street, Westminster, London, engraving from *The Builder,* 1853

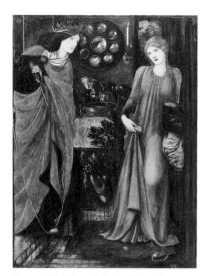

Fig. 23. Sir Edward Coley Burne-Jones, *Fair Rosamund and Queen Eleanor* (1861), cat. no. 87

practically every building that sprang up under his own influence.

Ruskin was one of the first critics to champion a small circle of British painters who selected their subjects from the Bible and medieval romances. The Pre-Raphaelite Brotherhood was formed in 1848, and as the name suggests, its members drew inspiration both in content and in style from the late Gothic and early Renaissance painters of the fourteenth and fifteenth centuries.[37] The weightless figures and dreamlike settings of Dante Gabriel Rossetti and Edward Burne-Jones (cat. no. 87; fig. 23) evoke a time past that is deliberately far more fantasy than historical reality. The Pre-Raphaelites' lack of interest in archaeological accuracy sets them apart from the prevailing currents in the Gothic Revival at the time, but they contribute an attention to execution—using luminous gold highlights to suggest a Trecento panel or the leaf of a manuscript—that draws upon Pugin's concern for craftsmanship, and signals a new direction.

Like Pugin and the Pre-Raphaelites, William Morris was disenchanted with modern, industrial Britain. An entrepreneurial designer and craftsman, Morris belonged to the Gothic Revival insofar as it opened his eyes to a medieval model of manufacture.[38] He was the leading figure in the Arts and Crafts Movement in interior decoration, which developed as both an outgrowth of and a reaction to the Gothic Revival in Britain. His return to a pre-industrial ideal of production by artisans followed the example of Pugin in his collaboration with skilled craftspeople to achieve an overall decorative program. The Arts and Crafts Movement stripped down vaguely Gothic forms to their essentials, creating a product that was fundamentally more vernacular than medieval per se, and advocated a more selective placement of objects in each room. Morris's designs for both tapestry and a relatively new form of decoration, wallpaper, took medieval motifs as their starting point, but infused in them a more abstracted, contemporary spirit.

In most histories of the Gothic Revival, the Arts and Crafts Movement represents little more than an epilogue. Its departure from unambiguously Gothic forms does suggest more than a simple phase in the larger scheme of the movement, but its exclusion is in part due to the fact that a definitive history of the Gothic Revival had already been written. Its author, Charles Locke Eastlake, was in fact to blame for much of the excess in Victorian interior decoration that Arts and Crafts partisans would decry. Eastlake's earlier *Hints on Household Taste in Furniture, Upholstery, and Other Details* (1868) popularized the domestic application of Gothic ornament, darkening interiors with mahogany accents and an overabundance of furniture. His *A History of the Gothic Revival* (1872) traced the style's resurgence through the High Victorian era, but even discounting the Arts and Crafts Movement, the revival had not fully run its course. Such major monuments as London's Tower Bridge (John Wolfe Barry and Horace Jones, 1886–94) and Liverpool's Anglican Cathedral (Giles Gilbert Scott, begun 1903) had yet to be commissioned, a fact still not addressed in Kenneth Clark's 1928 study of the movement. The Gothic Revival continued well into the twentieth century, although it would achieve its final flowering not in England, but rather on the American college campus.

Notes

1 Charles Locke Eastlake, *A History of the Gothic Revival* (London, 1872). Earlier writings provided a vast array of nomenclatures, but only the term "Neo-Gothic" today enjoys a popularity approaching that of "Gothic Revival," and its usage is far more common outside Britain (as the French "néo-gothique" or the German "Neugotik"). "Gothick" is generally used to distinguish the rather fanciful designs of the eighteenth century, including those of William Kent, Batty Langley, and Horace Walpole.

2 Kenneth Clark, *The Gothic Revival: An Essay in the History of Taste*, 3rd ed. (London, 1962), 7.

3 A fairly rigid, ecclesiastical revival of Romanesque architecture (akin to Pugin's Gothic) developed in the 1840s. Drawing its inspiration from San Zeno Maggiore in Verona, SS. Mary and Nicholas, Wilton, Wiltshire (1840–46), by Thomas Henry Wyatt and David Brandon, anticipates Ruskin's fascination with the styles of northern Italy. More characteristic of Romanesque's application in Britain is Alfred Waterhouse's Natural History Museum (1873–81) in South Kensington, London. However, the most influential branch of this movement originated in America with the architects Richard Upjohn and H. H. Richardson, and in this instance the British school was more derivative. Certainly the most important monument of the Byzantine Revival is John Francis Bentley's Roman Catholic Westminster Cathedral (1895–1903). In Germany, the *Rundbogenstil* revived both medieval and Renaissance forms that were based on the round arch.

4 This distinction is problematic, as one recent scholar has noted. See Giles Worsley, "The Origins of the Gothic Revival: A Reappraisal," *Transactions of the Royal Historical Society*, 6th ser., 3 (1993), 105–106.

5 This was also the case for three of Wren's "City churches"—St. Mary Aldermary, St. Alban, and St. Dunstan-in-the-East—which had remained sufficiently intact after the Great Fire to warrant a simple renovation in the original Gothic style. Wren admits that these were instances "where I was oblig'd to deviate from a better style," namely, Classicism. Cited in Christopher Wren the Younger, *Parentalia, or, Memoirs of the Family of the Wrens* (London, 1750), 302; see also the discussion in Lydia M. Soo, *Wren's "Tracts" on Architecture and Other Writings* (Cambridge, 1998), 217–219.

6 Wren's 1713 report on Westminster Abbey is given in Wren the Younger, *Parentalia*, 295–302.

7 On Hawksmoor's two drawings of this preliminary design, see Kerry Downes, *Hawksmoor* (London, 1959), 215, 277, nos. 149–150, pl. 86a.

8 Vanbrugh's castle-like volumes are best displayed at Castle Howard (1699–1712) and Blenheim Palace (1705–24), both built with Hawksmoor's assistance.

9 Margaret Jourdain, *The Work of William Kent: Artist, Painter, Designer, and Landscape Gardener* (London, 1948), 48–49, and Michael I. Wilson, *William Kent: Architect, Designer, Painter, Gardener, 1685–1748* (London, 1984), 154.

10 Walpole published the first edition of *The Castle of Otranto* anonymously, claiming that it was an authentic medieval work which had been rediscovered. The fact that Walpole disclosed his authorship in the second edition sets him apart from more notorious cases of literary deceit, like the infamous verses of "Ossian," a contemporary hoax purporting to be a genuine Celtic myth. See Wilmarth Sheldon Lewis, *Horace Walpole* (New York, 1961), 157–158; and Agnes Eleanor Addison, *Romanticism and the Gothic Revival* (Philadelphia, 1938), 46.

11 Horace Walpole, *A Description of the Villa of Mr. Horace Walpole* (Twickenham, 1784), 33.

12 This is Beckford's own characterization of Strawberry Hill. Cited in Lewis Melville, *The Life and Letters of William Beckford of Fonthill* (London, 1910), 299.

13 Walpole praised Wyatt's work as a worthy successor to his own. In a letter of 1794, he called Lee Priory "a child of Strawberry prettier than the parent." Cited in W.S. Lewis, ed., *The Yale Edition of Horace Walpole's Correspondence*, vol. 12 (New Haven, 1944), 111.

14 Gray had been a friend of Walpole, accompanying him as a youth on his Grand Tour and later on a number of his archaeological outings.

15 George Meikle Kemp received the commission for the Scott Memorial in 1838. The monumental spire was completed in 1846, two years after the designer's death. See Henry-Russell Hitchcock, *Early Victorian Architecture in Britain* (New Haven, 1954), 123, pl. IV 29.

16 Rickman was also a practicing architect, whose best known Gothic work (with Henry Hutchinson) is the New Court and adjoining "Bridge of Sighs" over the Cam at St. John's College, Cambridge (1825–31). See Addison, 61, 65.

17 Clark, 114. Unfortunately, Napoleon had recently allied the architectural language of Classicism to a régime more dependent on Imperial Rome than on democratic Athens.

18 Megan Aldrich, *Gothic Revival* (London, 1994), 45.

19 A debate erupted over Barry's and Pugin's respective roles in the overall design following the completion of the project (and the deaths of both architects). Pugin's son, Edward, claimed that the new Houses of Parliament were largely his father's work, prompting Alfred Barry to respond that his own father had been the building's true architect. In the course of this dispute, many of their fathers' letters and drawings (which might have been cited as evidence) mysteriously disappeared. See E. Welby Pugin, *Who Was the Art Architect of the Houses of Parliament?* (London, 1867); Alfred Barry, *The Architect of the New Palace at Westminster* (London, 1868); and Clark, 129–132.

20 Pugin's 1836 design is preserved in the collection of the Royal Institute of British Architects. The tower eventually built by Pugin's son at Scarisbrick Hall is radically different. See Alexandra Wedgwood, with Christopher Wilson, *Catalogue of the Drawings Collection of the Royal Institute of British Architects: The Pugin Family* (Farnborough, Hants., 1977), 74, no. [64] 1, fig. 36 (compare fig. 37).

21 Reported in Benjamin Ferrey, *Recollections of A. N. Welby Pugin, and his Father, Augustus Pugin; With Notices of their Works* (London, 1861), 247–248.

22 Eastlake, 187–192; Clark, 95–99; and John Summerson, *Architecture in Britain, 1530–1830,* 4th ed., rev. and enl. (Harmondsworth, Middlesex, 1963) 314–317.

23 Pugin provides a predictably severe attack on the tendency among Commissioners' churches to place frugality before propriety. See A. Welby Pugin, *Contrasts*, 2nd ed. (London, 1841), 48–49. St. Luke, Chelsea, London (1819–24), by James Savage, is perhaps the best of the lot.

24 David Watkin, *English Architecture: A Concise History* (London, 1979), 158.

25 Roger Dixon and Stefan Muthesius, *Victorian Architecture* (London, 1978), 194.

26 The prison structure reappears in another plate in *Contrasts* ("Contrasted Residences for the Poor") to illustrate the respective medieval and modern attitudes towards the poor. The benevolent spiritual community of the Catholic Church is juxtaposed with the heartless penal system of nineteenth-century England.

27 Clark, 120. Clark distinguishes between a "picturesque" and an "ethical" period in the history of the Gothic Revival, roughly corresponding to the eighteenth and nineteenth centuries, respectively.

28 Reported in Ferrey, 187.

29 Of course, these same manufacturing centers had already taken advantage of the popularity of Gothic ornaments by mass-producing inexpensive desktop items with Gothic detailing. Pugin was appalled by this "Brumagem Gothic," which he considered inappropriately commercial uses of the sacred Gothic style from "those inexhaustible mines of bad taste, Birmingham and Sheffield." See A. Welby Pugin, *The True Principles of Pointed or Christian Architecture* (London, 1841), 24.

30 At the Crystal Palace, Gothic forms had been confined to Pugin's court, but later glass structures permitted modernism and medievalism to unite in dramatic fashion, as in the train shed of Scott's St. Pancras Station in London (1865–71) or Deane and Woodward's University Museum at Oxford (1854–60).

31 Clark, 175.

32 In fact, Scott's own major treatise, *Remarks on Secular and Domestic Architecture, Present and Future* (London, 1857), represents an attempt to push the application of Gothic beyond church designs. See David Cole, *The Work of Sir Gilbert Scott* (London, 1980), 69–70.

33 In this post he succeeded William Butterfield; another leading Gothic Revivalist, William Burges, assumed the position in 1864. See Shirley Bury, "The Nineteenth and Early Twentieth Centuries," in *The History of Silver*, ed. Claude Blair (New York, 1987), 163.

34 Scott's Nikolaikirche in Hamburg had introduced much of the Continent to Britain's Gothic Revivalists, and the 1855–56 competition for the cathedral in Lille, France, was instrumental in bringing foreign influences back into Britain. Street lost this contest to William Burges and Henry Clutton, but in 1866 he defeated Burges in the competition for what is now his best-known building, the Law Courts in London. Burges's own design for the Law Courts is preserved in several illustrations by his frequent collaborator, Axel Haig. On the Lille competition, see Stefan Muthesius, *The High Victorian Movement in Architecture, 1850–1870* (London and Boston, 1972), 95–99, 117–119. On Burges and Haig, see J. Mordaunt Crook, *William Burges and the High Victorian Dream* (Chicago, 1981); and J. Mordaunt Crook and C.A. Lennox-Boyd, *Axel Haig and the Victorian Vision of the Middle Ages* (London and Boston, 1984).

35 George Edmund Street, *Some Account of Gothic Architecture in Spain* (London, 1865).

36 Muthesius, 18–20; and John Summerson, "William Butterfield, or, The Glory of Ugliness," in *Heavenly Mansions, and Other Essays in Architecture* (New York, 1963), 164. Butterfield had himself been a member of the Camden Society since 1844, and was one of the Ecclesiologists' favorite architects.

37 In their choice of artistic sources, the Pre-Raphaelites followed the Nazarenes —a group of German painters active in Rome in the early nineteenth century, headed by Johann Friedrich Overbeck.

38 Morris was also briefly a pupil of G.E. Street in 1856.

Making a Point:

Gothic Revival Architecture in America

Susan B. Matheson

The best place to look for the Gothic Revival style in America is in its architecture. From the 1830s until and in some cases beyond the end of the nineteenth century, the Gothic Revival inspired houses, civic buildings, colleges, and churches throughout the country.[1] It first appeared in an architectural climate in which Neoclassical was the only revival style, but by the end of the century, Gothic Revival was part of an eclectic historicism that included Greek, Roman, Italianate, Rustic, and even Egyptian revival architecture. The Gothic and Greek Revival styles were the most pervasive and the most lasting, arguably because they were the most imbued with meaning and thus fundamentally the most resonant with American thinking. Evidence from the patrons of the style, contemporary nineteenth-century writings, and the buildings themselves suggests that Gothic Revival, like Greek Revival, was chosen not simply for aesthetic reasons, but primarily because of the ideals it was believed to express. The aim of this essay is to explore the Gothic Revival style as it arose in American architecture, the reasons for its popularity, and the social and historical context in which it flourished. The focus will be on the period from the beginnings of the style in the 1830s until around 1875, when the idealism embodied in the early buildings had largely been replaced by a purely aesthetic interest.

American Gothic Revival architecture was born in Britain, where the style was beloved as an expression of the romantic and the picturesque and respected as a visible reminder that modern Britain's roots went deep into its medieval past.[2] Gothic style came to America with emigrating British architects such as Richard Upjohn and Frank Wills and through published designs by prominent figures such as A.W.N. Pugin. Because there were no medieval buildings or ruins in America to which local architects could turn for inspiration, books and periodicals, especially those by Andrew Jackson Downing for houses and by Pugin, Richard Upjohn, and a group called the New York Ecclesiological Society for churches, provided the designs and plans from which patrons and carpenters drew. Not inhibited by constant proximity to British architecture and history, American Gothic Revival architects and builders improvised. The style developed a vocabulary of its own, often in response to local climate and the materials at hand. Local carpenters added their own variations to the published designs, giving rise to the term "Carpenter Gothic."[3]

Once here, the style spread widely, finding favor not only among churchmen and the wealthy but also among civic leaders and the burgeoning middle class. As its popularity grew, the Gothic Revival style increasingly became a bearer of moral meaning, a symbol of high ideals. In the words of A.J. Downing, the "character expressed" by the Gothic style was "that of a man or family of domestic tastes, but with strong aspirations after something higher than social pleasures."[4] In a particularly American way, the Gothic Revival style made a point about the people who used it.

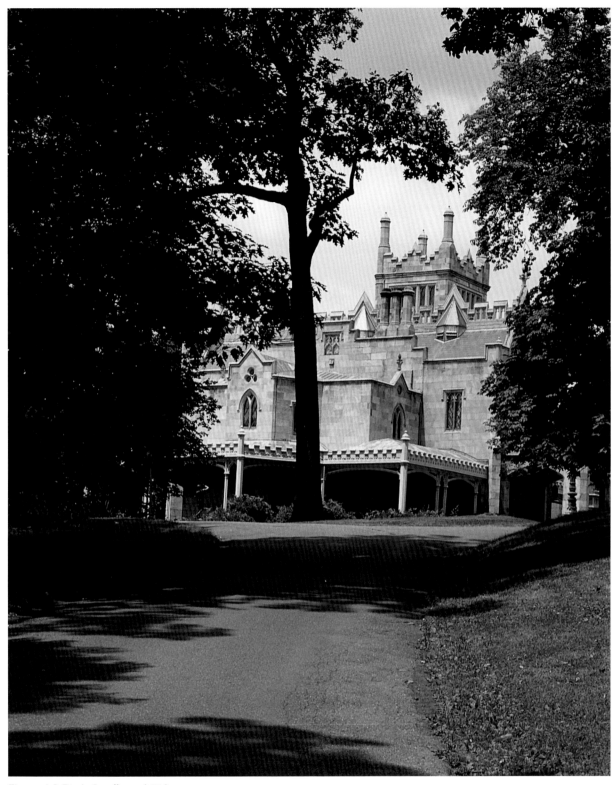

Fig. 3c. A.J. Davis, Lyndhurst (1865),
Tarrytown, New York

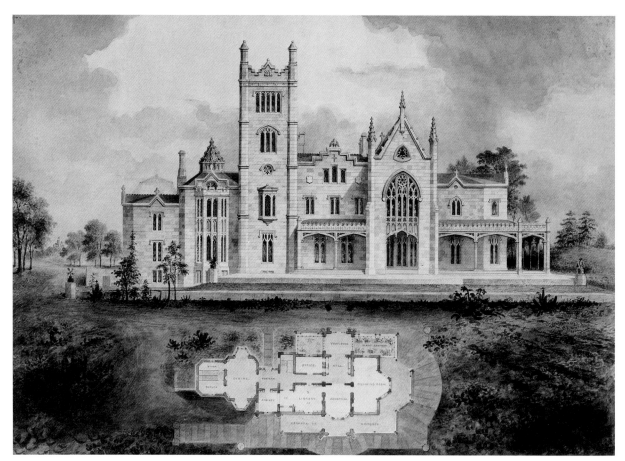

Fig. 3a. A.J. Davis, *Lyndhurst* (1865),
Tarrytown, New York, cat. no. 11

Domestic Architecture

 Andrew Jackson Downing (1815–52), although probably best known as America's first important landscape architect, was equally influential in the development of a system of stylish domestic architecture for houses set in landscapes outside the city.[5] Downing's books, *Rural Architecture* (1832), *Cottage Residences* (1842), and *The Architecture of Country Houses*, first published in 1850 and in its ninth edition by 1866, provided plans and elevations for modestly priced houses in a variety of styles. These he recommended as efficient, in good taste, true to their function and environment, in harmony with nature, and expressive of the noble values of family and rural life. Many of these houses were Gothic Revival. Downing's books included houses of his own design, others designed by Alexander Jackson Davis (1803–92)[6] and similarly prestigious, nationally-known architects, as well as a few by local architect-builders working outside the major metropolitan areas. To guide and encourage potential builders, Downing gave information on materials and costs of the designs. The houses in his books inspired patrons and builders across America, precisely as he intended (figs. 1a & 1b). The philosophical discussions with which he introduced the designs reveal the values that he believed could be expressed by architecture. Much of this emphasis on values was motivated by A.J. Davis, who contributed ideas as well as plans to Downing's work. The fact that these values were shared by so many Americans of Downing's day helps to explain the popularity of the Gothic Revival style.

 A.J. Davis published a similar book, *Rural Residences*, in 1838. In the introduction, he bemoaned the "bald and uninteresting aspect of our [rural] houses, … not only in the style of the house but in the want of connexion with its site—in the absence of …well disposed trees, shrubbery, and vines."[7] Davis was in complete sympathy with Downing on the desirability of improving the appearance of American domestic architecture and linking it more closely to nature. They were natural collaborators, and Davis provided many of the designs and drawings that illustrated Downing's writings. Seeking ways to improve American rural architecture, Davis and Downing turned to English sources, including both buildings and aesthetic theory. These were known to them through Downing's travels to England and through publications such as James Malton's *A Collection of Designs for Rural Retreats as Villas, Principally in the Gothic and Castle Styles of Architecture* of 1802/4, Thomas Rickman's *An Attempt to Discriminate the Styles of Architecture in England from the Conquest to the Reformation* (1817),[8] Augustus Pugin's *Specimens of Gothic Architecture* (1821–23) as well as the books by his more famous son A.W.N. Pugin,[9] and John Claudius Loudon's *Encyclopedia of Cottage, Farm and Villa Architecture and Furniture* (1833).[10] Loudon's *Encyclopedia* was a major source for Davis in particular. As a result, Davis recommended Gothic, Italianate, and a European "bracketed style" as producing houses in harmony with their surroundings,[11] while Downing espoused Rural Gothic as one of the styles most suited to domestic architecture.[12]

Fig. 1a. William Mason Thompson House (1845), Thompson, Connecticut, after A.J. Downing, *Cottage Residences* (1842), Design II

Fig. 1b. A.J. Downing, *Cottage Residences* (1842), Design II.

Downing and Davis also promoted the Gothic Revival style as picturesque and romantic, and thus especially suited to sites along the Hudson River and similar locations with picturesque wooded settings and views. For this emphasis they were particularly indebted to British sources. It was no accident that the Gothic Revival style was often adopted by the wealthy and powerful for their Hudson River estates. In his *Architecture of Country Houses* Downing wrote "picturesqueness denotes power."[13]

In addition, because the houses of such famous literary figures as Horace Walpole (Strawberry Hill, on the banks of the Thames outside London, cat. no. 2, p. 15, figs. 5 & 6) and Sir Walter Scott (Abbotsford, southeast of Edinburgh, p. 16, fig. 10) were built in the Gothic Revival style, it became a symbol of intellectual and artistic aspiration for prominent American patrons who wished to be seen in this light. A.J. Davis's first major Gothic commission, for example, designed in partnership with Ithiel Town, was a house for Robert Gilmor (Glen Ellen, 1832–33).[14] Gilmor chose the Gothic style as a direct result of his visits to Strawberry Hill and Abbotsford. Like its inspirations, Gilmor's house was built of stone in a castellated style with battlements and turrets. The site of Glen Ellen, on the banks of a river a few miles outside Baltimore, provided the picturesque component needed to complete the effect. Glen Ellen, although cruciform in plan, looks essentially rectangular from the outside, and it thus bears some similarity to the exterior appearance of Strawberry Hill. Both have relatively flat elevations with Gothic details applied to the surface.

Davis's castle style villas for his numerous wealthy patrons are among the most impressive examples of American Gothic Revival architecture. Beginning with relatively simple early designs, he developed increasingly complex and irregular plans that echoed the rambling medieval castles of Britain. Leading the way to Davis's later designs is Knoll, built on the banks of the Hudson for General William Paulding (Tarrytown, New York, 1838, cat. nos. 10, 17, fig. 2, later called Lyndhurst).[15] Although essentially cruciform in plan like Glen Ellen, it is totally different in outward appearance. At Knoll, Davis introduced a large central gabled entrance and porte-cochère that rises above the roof line and dominates the façade. He added a veranda that wraps around the south end of the house, a picturesque element that he used regularly from this point onwards, especially in his cottages, or as Downing sometimes called them, "cottage-villas."[16] Downing illustrated Knoll in the 1841 edition of his *Landscape Gardening*, praising it as corresponding "with the best examples of the Tudor period."[17]

General Paulding exemplifies the type of wealthy civic leader who often became a patron of the Gothic Revival style. A brigadier general in the War of 1812, he was mayor of New York for two terms and then a congressman. He was related by marriage to Washington Irving, some of whose writings represent the Gothic Revival in literature. General Paulding's son, Phillip, inherited Knoll in 1854, and ten years later he sold the house to George Merritt, a wealthy New York businessman.

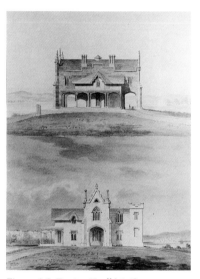

Fig. 2. A.J. Davis, *Knoll* (1838), Tarrytown, New York, cat. no. 10

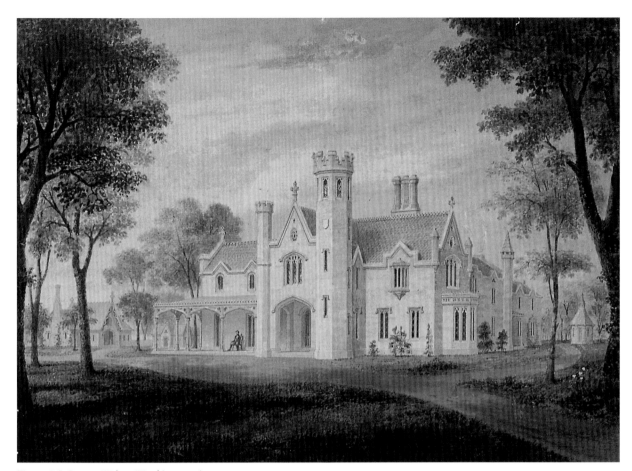

Fig. 4. A.J. Davis, *Walnut Wood* (1846–50),
Bridgeport, Connecticut (demolished),
cat. no. 12

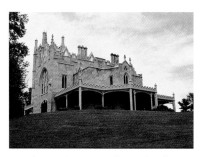

Fig. 3b. A.J. Davis, Lyndhurst (1865), Tarrytown, New York

In 1865, Merritt commissioned Davis to design a major expansion of Knoll, which the new owner renamed Lyndenhurst, later shortened to Lyndhurst (cat. no. 11, figs. 3a–c). Davis nearly doubled the size of the house, adding a new wing with a large Gothic Revival dining room, enlarging and changing the functions of other rooms, expanding the entrance, and extending the veranda. Both the axis and the visual focus of the house were shifted, increasing the picturesque irregularity of the floor plan and the visual interest generated by the massive vertical towers and windows. Davis added a tall square tower to the side facing the river that reinforced the castle-like appearance of the building and dominated its skyline. Even today the tower makes the house a prominent landmark when seen from the Hudson River and the Tappan Zee Bridge. In spite of the expansion, however, the house remains one of human scale, with livable spaces enhanced by the light from its many windows. Its spacious verandas and rolling lawns invite one to appreciate its setting overlooking the Hudson, and they embody the close relation of domestic country architecture to nature that was espoused by both Davis and Downing.

Several houses that Davis designed between Knoll and Lyndhurst, although preserved only in drawings, show the development in style between the two. Among these are Walnut Wood (1846–50, cat. no. 12, fig. 4), designed for Henry K. Harrel and built on a wooded site in Bridgeport, Connecticut, and Kenwood, designed for Joel Rathbone in 1842 for a site south of Albany.[18] In both, a large gabled entrance was flanked by a tower, and a veranda extended from this entrance along the façade and around the end of the house. The prominence of the verandas in these designs, although unexpected in any imagined recreation of a castle, reflects the architect's intention to make these homes conducive to happy family life in the same way that both he and Downing used the veranda in their smaller country villas and cottages. In Downing's words, "The larger expression of domestic enjoyment is conveyed by the veranda,"[19] and he recommended them for all but the most humble cottages. At both the Harrel and Rathbone houses, and even more so at Knoll/Lyndhurst, the veranda was also a means to link the architecture to nature. The verandas extended the interior living space out of doors, while at the same time they provided a sheltered transition to the outdoor space that brought nature in through the open windows. So successful was this transition at Knoll/Lyndhurst that it has been called the first example in America of the interpenetration of interior and exterior space best known from the prairie houses of Frank Lloyd Wright.[20]

Another variant of the castellated villa was exemplified by Ericstan (1855–59), a house designed for John C. Herrick that was situated, like Knoll/Lyndhurst, in the picturesque landscape of the Hudson River Valley in Tarrytown, New York. Ericstan was dominated by massive round towers with extensive battlements, making it remarkably castle-like in appearance.[21] One of the few Davis castle style villas still standing is Castlewood (1857–59), the house designed for Joseph Howard in Llewellyn Park, a 500-acre planned and elaborately landscaped suburban community in West Orange, New

Jersey, discussed further below. Anchored by a massive round central tower that dominated the design, Castlewood appears heavier and more fortified than Lyndhurst. Like its near contemporary Ericstan, which has a similar heavy round tower, Castlewood may owe a debt to Windsor Castle (cat. nos. 7 & 8, p. 21, fig. 13). Although more like castles than Lyndhurst or Walnut Wood, these two nevertheless have extensive verandas to soften their formidable appearance.

Architects other than Davis also designed in the castle style.[22] Hallock House in New Haven, designed by Sidney M. Stone for Gerard Hallock, a wealthy newspaperman and part owner of the *New York Journal of Commerce*, in 1836 (cat. no. 13, fig. 5; other views show a larger tower) is an early example.[23] Like Paulding, the owner of Knoll, Hallock was prominent both in business and in civic life. He is credited with inventing the special edition of newspapers known as the "Extra," originally a late-breaking notice of shipments arriving by sea. Hallock was active in the anti-slavery movement before the Civil War, buying and freeing about 100 slaves. He founded a school in Salem, Massachusetts, provided aid to needy churches in the South, and organized and built the South Church in New Haven. Hallock's house stood on forty acres of land on Orchard Point until his death, when it was bought by the New York and New Haven Railroad and moved.

Richard Upjohn, a British-born American architect best known for Trinity Church in lower Manhattan and his other Gothic Revival churches, also designed a castellated villa early in his career, a house named Oaklands which was begun in 1835 for R.H. Gardiner in Gardiner, Maine.[24] Built of local granite, it has a somewhat Georgian façade that is transformed into Gothic style by battlements, buttresses, and hooded windows. The house was singled out by Nathaniel Hawthorne in his *American Notebooks*, where he states that it "well deserves the name of castle.[25]" Also by Upjohn is Kingscote on Bellevue Avenue in Newport, Rhode Island (1839, cat. no. 14, figs. 6a & 6b).[26] It is a complex house whose front elevation combines the sturdy tower and battlements of the castle style with the gables, chimney-pots, vergeboards, and verandas of Gothic Revival cottages. On balance, it is more a cottage than a castle. Unlike its granite predecessor, Oaklands, Kingscote was built of wood; Upjohn published detailed instructions on rendering Gothic ornament in wood in his book *Upjohn's Rural Architecture* (1852). Built for George Noble Jones of Savannah, Georgia, Kingscote was the first of the large summer houses that transformed Newport in the later 19th century. The house was sold in 1864 to William Henry King, who enlarged it to its present state and gave it its name. Even now, Kingscote remains an island of modest good taste in a sea of overpowering richness.

Other Gothic Revival houses are so individualized that they have no precedent in drawing or stone. One of the most famous Gothic Revival buildings in New England, the so-called Wedding Cake House in Kennebunk, Maine (ca. 1800, with Gothic details added ca. 1850, photograph p. 88), was a typical Federal style house that was transformed through the addition of a shell of Gothic tracery. The Gothic layer was designed by

Fig. 5. Sidney M. Stone, Gerard Hallock House (1836), New Haven, Connecticut (demolished), in a painting by an unknown artist (1836–85), cat. no. 13

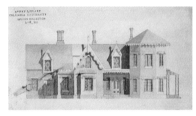

Fig. 6a. Richard Upjohn, *Kingscote* (1839), Newport, Rhode Island, cat. no. 14

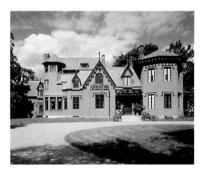

Fig. 6b. Richard Upjohn, Kingscote (1839), Newport, Rhode Island

the owner, George Bourne, evidently with no other aim than to keep up with current fashion. As its name suggests, the Gothic appearance of the house is based purely on its surface ornament—sheer confection.

Oddly, for all his devotion to Gothic style in domestic architecture, Downing did not approve of the castle style for houses. "Battlements," he said, "have no meaning in the domestic architecture of this age,"[27] and "almost all imitations of castles must, as private dwellings, be petty in this country."[28] The Gothic form that Downing favored was the country villa, especially the villa built in cottage style, a type of house ultimately based on the English country cottage. "If we are to choose among foreign architecture, our preference will be given to modifications of the Rural Gothic, common in England and Germany, with high gables wrought with tracery, bay windows, and other features full of domestic expression."[29] Downing sought the "upward, aspiring, imaginative feeling indicated in the pointed or Gothic styles of architecture."[30] His reason for choosing the Gothic style for rural houses was the role he saw for the country villa in American life. "The villa is the most refined home in America—the house of its most leisurely and educated citizens. … It is in such houses that we should look for the happiest social and moral development of our people. … The villa should indeed be a private house, where beauty, taste, and moral culture are at home."[31] Here Downing is describing the ideal sort of life toward which he believes Americans should strive, a life driven by intellectual and cultural aspirations. To Downing, the country villa embodied these aspirations, and by recommending it he recommended the aspirations as well. It was an elitist view, admittedly, but not a materialist one.[32]

The high ideals that the villa was supposed to express had a definite impact on the architectural design of these buildings. The plans published in Davis's *Rural Residences* and Downing's *Architecture of Country Houses*, as well as the adaptations of them by local architects, patrons, and builders, express these ideals in a variety of ways. Particularly important is the recommendation for the "devotion of a part [of the house] to a library or cabinet sacred to books."[33] This suggestion was taken seriously by the owners of both Knoll and Lyndhurst, who had extensive libraries, and by William Rotch, whose Davis-designed villa in New Bedford, Massachusetts (cat. no. 15, figs. 7a & 7b) boasted a library that was the largest room in the house. Façades of these villas were frequently symmetrical, like that of the cottage-style Rotch house, expressing harmony in the balance between the high central gable over the entrance and the broad veranda that spans the façade. Gables were bold and spirited. Verandas expressed domesticity. Downing and Davis admired the truthfulness of Gothic rural architecture and tailored their recommendations concerning materials to reinforce this honesty.[34] Colors and materials were to be in harmony with the natural surroundings: "avoid colors which nature avoids."[35] Specific types of stone and locations from which to obtain it were recommended, as were methods of surfacing with wood such as board-and-batten. Downing, being a landscape architect, of course also recommended appropriate plantings.[36]

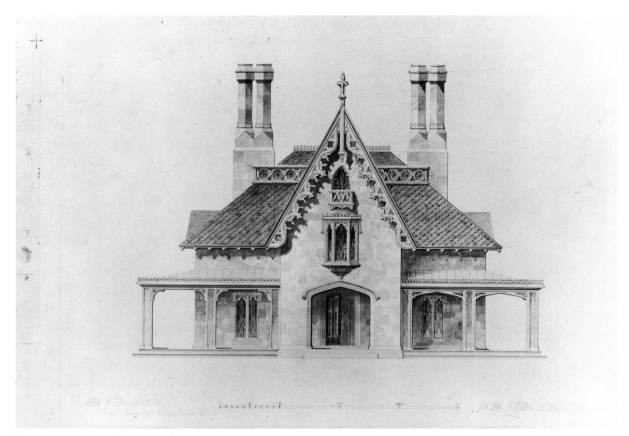

Fig. 7a. A.J. Davis, *William J. Rotch House*
(1845), New Bedford, Massachusetts,
cat. no. 15

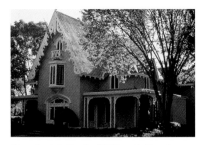

Fig. 7b. A.J. Davis, William J. Rotch House (1845), New Bedford, Massachusetts

The types of people who commissioned Gothic Revival villas were very much the sort of patron whom Downing and Davis had imagined: educated and cultured, with good taste, high moral values, and often important civic positions. William J. Rotch, whose house has already been mentioned, is a good example. W.J. Rotch was the mayor of New Bedford, a thriving mill town and seaport that had been at the heart of the Massachusetts whaling industry.[37] Rotch's grandfather had also been mayor, and he had built a Greek Revival mansion with elaborate gardens for himself in 1833, a building that still stands as one of the city's grandest houses. Ironically, it was one of the first houses in America designed by Richard Upjohn, predating his Gothic Revival Oaklands by two years. The younger Rotch, apparently inspired by houses he had seen in the Hudson Valley, engaged A.J. Davis in 1844 to design a new Gothic Revival house as his own residence.

The Rotch house was published in Downing's *Architecture of Country Houses*, Design XXIV, as a recommended design for a "Cottage-Villa in the Rural Gothic Style."[38] Downing notes that the house cost $6000. Both Rotch's grandfather and his Quaker neighbors criticized him for his choice of style, but perhaps he took comfort from Downing's statement that "the character expressed by the exterior of this design is that of a man or family of domestic tastes, but with strong aspirations after something higher than social pleasures."[39] Downing also makes much of the fact that the library is larger than either the drawing room or the dining room. William J. Rotch was not ostracized by his fellow citizens for his choice of style, however: he was elected mayor in 1852, and he served as president of the Friends' Academy for 42 years.

The social and civic importance of Davis's patrons often meant that his houses stood with those of other prominent citizens. An example of this is the Commodore Charles Green house, located in the historic district on Main Street in South Windsor, Connecticut (1851, fig. 8), where it stands with 18th and other 19th century houses of prosperous families and town leaders. Commodore Green (1812–87), the son of the owner and editor of the *Connecticut Gazette* of New London, was a career naval officer whose commands included the "Fulton," America's first steamship, in 1852, and a sloop of war during the Civil War.[40] He married Sophia Haskell Tudor of South Windsor, acquired property from her family there, moved the 18th century house that came with it, and commissioned A.J. Davis to design a Gothic style cottage villa for him. Mrs. Green designed the kitchen. The family remained in the house for three generations. The house is a characteristic Davis design, with a balanced façade featuring a high central gable and a veranda, a board-and-batten exterior, and a cruciform plan.

Other Davis villas were commissioned by eminent citizens. Among those still standing are the Henry Graham Thompson House, in Thompsonville, Connecticut (1845, photograph p. 84), built for the head of the Bigelow Carpet Mills nearby; the John Angier house in Medford, Massachusetts (1842–44, photograph, p. 86), on which Mr. Angier assisted with the design; the Henry Delamater House, in Rhinebeck, New York (1844, photograph p. 90); and the Henry Wood house, in Bedford Hills,

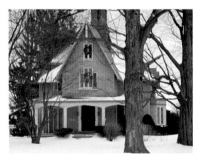

Fig. 8. A.J. Davis, Commodore Charles Green House (1851), South Windsor, Connecticut

New York (1846–47). Davis houses are known from Maine to Virginia and North Carolina, and as far west as Michigan and Ohio.[41]

The Davis style seemed to be everywhere. Three other Gothic Revival houses connected in some way with him survive in New Bedford. All three stand near Davis's Rotch house, postdate it, and were likely inspired by it; two have direct connections to W.J. Rotch himself. One, the James H.C. Richmond house, may be directly associated with Davis (possibly designed by him in 1845, but the records are unclear). One was built for another prominent citizen, William C. Coffin, the Treasurer of the New Bedford Institution for Savings.

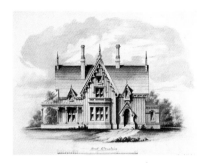

Fig. 9. Henry Austin, *Design for a Gothic House* (ca. 1850), cat. no. 16

Numerous cottage style villas in the Davis manner were designed and built by other architects and their patrons. Richard Upjohn, architect of the elaborate Kingscote in Newport mentioned above, designed a villa very close to those of Davis,[42] as did Henry Austin, New Haven's most prominent architect of the mid-nineteenth century (cat. no. 16, fig. 9). Even more such houses were based on the designs published by Downing in *Cottage Residences* (see figs. 1a & 1b) and *The Architecture of Country Houses*; many of these published plans were in fact by Davis.

Many of the houses built from the published designs were based on the simpler plans in these volumes, but others, like the Moses Fowler House in Lafayette, Indiana (1852, fig. 10) were developed from the designs for larger, more elaborate homes.[43] Moses Fowler was born on an Ohio farm in 1815, clerked for three years to learn business skills, then moved to Indiana where he became the business partner of John Purdue, later founder of Purdue University. After the demise of the partnership, Fowler amassed a fortune of millions on his own. He served as advisor to the Governor during the Civil War, as president of several banks, and for twenty-five years as trustee of Wabash College in Crawfordsville, Indiana.

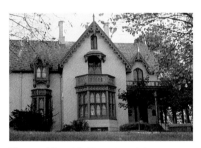

Fig. 10. After A.J. Downing, Moses Fowler House (1852), Lafayette, Indiana

Another prominent patron of the Gothic Revival style was Senator Justin Smith Morrill of Vermont. Morrill, the self-educated son of a blacksmith who served in the U.S. House of Representatives from 1854–66 and in the U.S. Senate from 1866 until his death in 1898, is best known as the chief sponsor of the Land Grant Act of 1862, which provided each state with a land grant college to offer practical and liberal college education to farmers and other laborers. Cornell University and Yale's Sheffield Scientific School were among the Land Grant Colleges. During his time in Washington, Morrill was an outspoken advocate for improving the quality of architecture in the city, and as Chairman of the Senate Building committee he was responsible for the construction of the Library of Congress and other landmark buildings.

Morrill designed his Gothic Revival house in Strafford, Vermont himself (photograph, p. 86).[44] Although he owned Downing's *Architecture of Country Houses*, he did not follow any of its designs precisely, preferring to combine and adapt them to suit his needs. The house, designed and built between 1848 and 1853 and enlarged in 1859, is irregular in plan. It is set in elaborate grounds that were also designed by Morrill. Several of the out buildings that supported farming activities also feature Gothic details. The

exterior of the house combines details familiar from Davis's villas with battlements taken from Gothic sources. Inside, only the library, added as a separate wing in 1859, is in Gothic style. It is adorned with Gothic woodwork and features French stained glass windows, specially commissioned by Morrill, that show picturesque views of the ruins of Holyrood Abbey in Edinburgh. Morrill used the library both for his books and for the memorabilia associated with his political career. As with the Rotch house, it is the largest room in the house.

Roseland Cottage in Woodstock, Connecticut (1846, fig. 11), still flanked by the beautiful gardens from which it took its name, offers perhaps the most complete picture of a country villa built by the prominent and cultured citizen of Downing's ideal world. The house was designed for Henry C. Bowen by Joseph Collins Wells, like Upjohn a British-born architect, after the models of Davis and Downing.[45] Built of board-and-batten construction and painted a rose color of which Downing approved, the house is dominated by its gables and projecting verandas and porte-cochère. Unlike many Gothic villas, it has a predominantly Gothic interior, with notable woodwork in the entryway, hall and staircase, and first floor, and stained glass in the parlor. Much original Gothic Revival furniture survives, including major pieces in the hallway and parlor, and complete bedroom suites upstairs in the simpler style recommended by Downing for the country.[46]

Bowen made his fortune in the dry goods business, but he made his reputation as one of the founders and later the sole owner of *The New York Independent*, a weekly newspaper dedicated to fighting slavery and promoting the Congregational Church. *The Independent* was ultimately one of the most influential political and religious journals of its day, and its contributors included prominent writers such as Henry Ward Beecher, the famous abolitionist preacher (later appointed editor of the journal by Bowen and pastor of the church Bowen founded in Brooklyn), Horace Greeley, William Lloyd Garrison, Elizabeth Barrett Browning, and John Greenleaf Whittier. Bowen arranged Abraham Lincoln's first major speech in New York, an event that catapulted Lincoln to fame overnight, and Bowen remained active in the Republican party until his death. Roseland Cottage became famous for its annual Fourth of July party, which featured speeches by orators such as Henry Ward Beecher and Oliver Wendell Holmes, as well as lavish food (but no alcohol), and it counted five U.S. presidents among its guests.

Bowen was one of the founders of the Congregational Church of the Pilgrims in Brooklyn, New York, and as such he was one of the committee responsible for engaging Richard Upjohn as architect for the new church. Given both Upjohn's commitment to Gothic style for church architecture and Bowen's choice of Gothic style for his own home, it might be presumed that the Brooklyn church would be built in the same style. In fact, however, it was the first building designed in the Romanesque style in America. Gothic style was identified with the Episcopal church, and Bowen and his colleagues wanted something different. Upjohn, still wanting a medieval style, gave them Romanesque.[47]

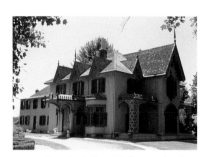

Fig. 11. Joseph Collins Wells, Roseland Cottage (1846), Woodstock, Connecticut

Bowen was a major civic benefactor for Woodstock, his home town, planting and maintaining hundreds of trees and shrubs on the town common, which faced his house, and building a pleasure ground with a lake, Roseland Park, which he donated to the town. In his devotion to landscape in both his public and private lives, coupled with his political and intellectual prominence, Bowen perfectly embodied the character of the man whom Downing and Davis envisioned as a patron of the Gothic Revival style.

Downing and Davis also inspired the remodeling of older homes into Gothic style. An eighteenth-century house in Ho-Ho-Kus, New Jersey, known as The Hermitage and once owned by Aaron Burr, was remodeled by William Ranlett as a Gothic villa for Dr. Elijah Rosenkrantz in 1847 (photograph, p. 91). Dr. Rosenkrantz was an early member of the Bergen County Medical Society. The New Jersey brownstone used for the house was a material specifically recommended by Downing.

Fig. 12. A.J. Davis, *Designs for Tables and Chairs for Knoll* (ca. 1838), cat. no. 18

Downing also gave recommendations for interior design and furniture. In his view, the architect should carry out the interior of the building in the same style as the exterior.[48] As a result, we find A.J. Davis designing interiors and both Davis and Richard Upjohn designing furniture. Houses like Knoll/Lyndhurst, and Roseland Cottage feature both Gothic Revival interior detailing and furniture. Tudor arches were important Gothic elements in interiors, framing doorways and fireplaces as in, for example, Kingscote and the Rotch House.[49] The master bedroom at Lyndhurst fulfills Downing's prescription for a Gothic space that is "a lofty bedroom, combining spaciousness and good effect with a fine circulation of air."[50] Davis's dining room at Knoll (cat. no. 17, ill. p. 71) and his second version for Lyndhurst were completely Gothic Revival in style to the last detail. Designs for furniture by Upjohn and Davis are preserved (e.g., cat. no. 20), including Davis's drawings for chairs and tables for Knoll (cat. no. 18, fig. 12).

In practice, few homes were as stylistically consistent as Downing would have wished. Most families then, as now, had a mixture of stylistic elements in their homes, combining treasured heirlooms with the latest fashions. The Gothic Revival style was often featured in a specific room, most commonly the library or the hall, in houses with Gothic Revival exteriors as well as those in Greek Revival and other styles. In the Justin Morrill House, for example, although the exterior is Gothic, the library is the only Gothic Revival room. Other houses reserved the Gothic style solely for the exterior. The Delamater House in Rhinebeck, New York (1843, photograph p. 90), for example, an A.J. Davis design closely based on a design by Downing, has a totally Greek Revival interior, and both the Green-Meldrim House in Savannah (1856) and the Morse House in Portland, Maine have Gothic exteriors with interiors in a variety of non-Gothic styles.[51]

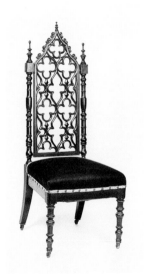

Fig. 13. American, 19th century, maker unknown, *Side Chair*, cat. no. 23

American craftsmen and furniture companies produced a wide variety of Gothic pieces, especially for use in the home, but also for use in civic and educational buildings and churches. In a domestic context, side chairs for libraries, halls, and dining tables were particularly popular (cat. nos. 23 & 24, fig. 13). Bookcases such as the mahogany desk and bookcase by John and

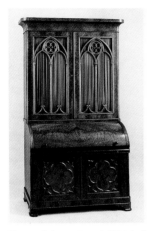

Fig. 14. John & Joseph W. Meeks, *Desk and Bookcase* (1836–ca. 1855), cat. no. 21

Fig. 15. American, 19th century, maker unknown, *Pair of Andirons*, cat. no. 25

Joseph W. Meeks of Philadelphia (cat. no. 21, fig. 14), would have stood in a library or parlor, a free-standing version of the "cabinet sacred to books" recommended by Downing.[52] Side tables, dining sets, and bedroom suites in elaborate carved or simple painted styles were also produced. A looking glass might conveniently adorn a hall (cat. no. 22). Gothic fireplaces were complemented by andirons in the shape of Gothic towers (cat. no. 25, fig. 15). Gothic Revival tableware, including silver, glassware, and china, was either crafted in America (cat. nos. 35, 38–40) or imported from England (cat. nos. 32–34, 36, 37) to echo the style of the dining room and its furniture. Any one of these pieces might just as well have been treasured on its own. Most were chosen for style or appearance, but some included homilies, e.g., "It is a good tongue that says no ill and a better heart that thinks none" (cat. no. 33), a tradition in American tableware dating back to the Pilgrim fathers.

Downing's recommendations for rural architecture extended beyond villas for the wealthy, and in *The Architecture of Country Houses* he devoted a chapter to farm houses. He emphasized that farm houses, even large ones for prosperous farms, should not borrow carved Gothic detailing from villas; he was seeking a simpler style that was truer to the functional agrarian identity of the farm house. While he did not provide recommended designs for farm houses as he had done for villas and larger "country gentleman's" houses, he did suggest the use of the newly-developed "bracketed style" that Davis had adapted from Swiss cottages. In spite of Downing's proscription, Gothic features did find their way into farm houses. Included among them is a pointed lancet window known from a photograph to have adorned the board-and-batten house in Eldon Iowa (1881–82) immortalized by Grant Wood in his icon of American farm life, *American Gothic*.[53]

The Gothic Revival was one of several major styles recommended by Downing and Davis in their writings, and when Davis turned his hand to designing an entire residential community, he combined Gothic with some of the others, notably Italianate, Bracketed, and Rustic. Llewellyn Park, a 500-acre suburban development West Orange, New Jersey and the first planned suburban community in America, was the embodiment of Downing's book both in its focus on the harmonious relationship between architecture and nature and in its emphasis on the picturesque.[54] Situated in a hilly wooded park, the site offered romantic settings and views of Newark Bay. The park was commissioned by Llewellyn Haskell, a New York pharmaceutical entrepreneur whose philosophical interests lay in the relationship between man, nature, and the community, especially as expressed in the utopian theories of Charles Fourier.[55] Haskell envisioned Llewellyn Park as an ideal community. Davis was instrumental in starting the community, and as a Swedenborgian he shared Haskell's idealistic views about community life and the relation of man and nature.[56]

Davis designed a variety of buildings for Llewellyn Park between 1857 and 1869, including a school house, lyceum, temple, conservatory, and several gate houses (all in Rustic style), and although not all were built, some of those that were not or were subsequently destroyed survive in descrip-

tions and drawings. Rustic was the style that both Davis and Downing believed was closest to nature, and it was the style advocated by many in the "villa movement." To set the tone for the whole community, Davis designed a Rustic gate house for the Park's entrance. His house for Llewellyn Haskell, perched atop a ridge with spectacular views, was similar in style. Both featured round towers with conical roofs, built of local rock and wood, with rough tree trunks supporting the house's porch roof.

Davis's Gothic Revival work in Llewellyn Park is best represented today by two surviving houses, Castlewood, the castle style villa of 1857–59 for Joseph Howard, described above, and the Edward V. Nichols cottage of 1858–59. The Nichols house is a classic Davis cottage style villa, with a gabled central entrance, spacious veranda, and a pair of triple chimney-pots. Another castellated villa, the Anderson House, was also designed by Davis in 1857. According to Jane Davies's invaluable list of Davis's works,[57] other cottages and villas were designed in both the Gothic and the Italianate styles. The fact that Davis designed his own summer house, Wildmont (1878), which stood outside and above Llewellyn Park, in the Gothic Revival style speaks eloquently for his own preference.

Haskell worked directly with Davis, and since he also planned the development as an investment, the styles chosen for the houses were clearly thought to be appealing. Haskell retained Davis to design several other investment houses for him near Llewellyn Park, in West Bloomfield (now Montclair). These were mostly Gothic or Italianate. Other Gothic houses were built nearby for individual clients.

Davis designed clusters of Gothic Revival villas and cottages elsewhere for other patrons. An early plan for a residential community, Ravenswood, across the East River from Manhattan (1836), although never built, was to include both Gothic and Greek Revival villas as well as a church. A later project, comprising a group of four or five Gothic Revival villas in New Rochelle, New York (1858–63) and started at about the same time as Llewellyn Park, was actually executed; the fate of another, including attached houses and combining Gothic with other styles, designed for a client in Brooklyn (1858–75), is unclear. At about the same time, Davis designed the Gothic Revival House of Mansions in Manhattan, a block of eleven houses as a single unit that covered an entire block of Fifth Avenue between Forty-first and Forty-second Streets (1858). It was a prototype of the modern apartment building and one of Davis's few significant urban residential commissions.

Civic Architecture

The Gothic Revival style was less popular for civic than for residential architecture, but the buildings for which it was chosen often reflect the same high ideals that inspired its use for the houses of prominent civic leaders. This was particularly true of government buildings. One of the first examples was the Old State Capitol of Georgia, designed by Major-General Jett Thomas, an officer in the state militia who was also a professional contractor.[58] Portions of the battlemented stone structure date from 1807,

Fig. 16a. Richard Michell Upjohn, *Connecticut State Capitol* (1875), Hartford, Connecticut, interior, cat. no. 43

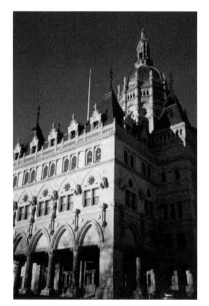

Fig. 16b. Richard Michell Upjohn, Connecticut State Capitol (1875), Hartford, Connecticut

although it was not completed until 1833. The Georgia Assembly met in this building until 1868. Since then it has served as a courthouse and the home of the Georgia Military Academy. Virtually destroyed by fire, the building was reconstructed in 1942 and still stands.

The most famous civic building in the Gothic Revival style was undoubtedly the Old Louisiana State Capitol in Baton Rouge, by James Dakin (1847–49, rebuilt in 1880–82 after burning during the Civil War).[59] Dakin began his architectural career as a partner with A.J. Davis and Ithiel Town, from whom he learned both Greek and Gothic Revival, but he soon moved to New Orleans and did his most important work there. Much of it was Greek Revival. His Gothic design for the State Capitol was a surprise, and according to his own statements about it, surprise was his goal—he wanted something different from the Classical tradition that everyone had come to expect for such buildings. His justification was economy (much of the construction was of cast iron).[60] The reaction to Dakin's building was mixed, and in one prominent case hostile: Mark Twain wrote "Sir Walter Scott is probably responsible for the Capitol building, for it is not conceivable that this little sham castle would have been built if he had not run the people mad, a couple of generations ago, with his Medieval romances. The South has not yet recovered from the debilitating effects of his books."[61]

Twain's comments reflect a perception held by many in the nineteenth century that government buildings should be Greek because Classical style expresses the democratic spirit, a persistent idea embodied in the Classical buildings that dominate the U.S. and many state capitals today. Judging from their designs, Ithiel Town and A.J. Davis shared this view.[62] But a strong trend toward Gothic style for civic buildings existed in Britain in the mid-nineteenth century, most notably in the new Houses of Parliament that were rising in London at just this time (cat. no. 41, p. 22, fig. 14). The choice of the Gothic style for Parliament made a strong statement about the appropriateness of the style for civic buildings, and the message, embodied in Sir Charles Barry's design, was clearly heard across the Atlantic. In Connecticut, for example, the old Greek Revival State House in New Haven, by Ithiel Town, was replaced by the Gothic Revival Connecticut State Capitol in Hartford, by Richard Michell Upjohn (1875, cat. nos. 42 & 43, figs. 16a & 16b), the son of the famous church architect Richard Upjohn. The interiors and furnishings of the Houses of Parliament were designed by A.W.N. Pugin, whose theoretical writings on the moral and ethical nature of Gothic Revival architecture, discussed by Derek Churchill in his essay in this volume, were read and assimilated by American architects and their patrons.[63]

Prototypes for Gothic Revival government buildings can also be found in other European structures, both Gothic and Gothic Revival. Numerous Gothic city halls survived in northern Europe in the nineteenth century to be seen by American travelers, and it is not unlikely that these inspired town halls in American communities. Robert Dale Owen, in *Hints on Public Architecture*, his defense of Gothic architecture as an appropriate national style for America, states "The old Town-halls of the European

Continent, those especially in Belgium, furnish examples of a variety of Gothic, well suited, under many circumstances to the public buildings of a city."[64] Owen also emphasized the practical advantages of Gothic over Classical style for modern buildings, in which windows and mechanical ventilation systems were important components. A.J. Davis submitted a Gothic Revival design for City Hall in Brooklyn (1835), although it was not executed.[65] Other buildings, such as New Haven's City Hall (Henry Austin, 1861, cat. no. 44, figs. 17a & 17b), in Venetian Gothic style, looked to southern European sources that, influenced by John Ruskin, were already inspiring cultural buildings in America.

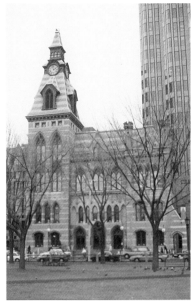

Fig. 17a. Henry Austin, City Hall (1861), New Haven, Connecticut

The choice of Gothic Revival for certain other types of civic buildings was far less laden with moral meanings, seeming instead to have been a combination of practicality and whimsy. The famous Chicago Water Tower (William W. Boyington, 1869), now a city icon, along with water and fire towers in Milwaukee (1874), Baltimore (1853), and Philadelphia (ca. 1855),[66] offer picturesque solutions to the need to erect a tall tower in an urban setting. The Chicago Water Tower and its subsidiary building across the street, built of a soft pale stone that makes them resemble sand castles, are the most elaborate. The tall massive Gothic pylons of the Brooklyn Bridge (John A. Roebling, 1867–83), while introduced for structural reasons, provide a vivid vertical thrust to balance the sweeping cables and long horizontal span. Armories, such as that designed by A.J. Davis for New York (Elm and White Streets, 1850–52), must have been conceived as direct descendants of medieval castle keeps.

Hospitals, asylums, and prisons were also built in the Gothic Revival style. European sources may be cited here as well, including, for example, the medieval monastic hospitals in Belgium and France or the most notorious French prison of them all, the Bastille. One of the earliest Gothic Revival prisons in America, if not the earliest, stood in Auburn, New York (before 1818), the town in which A.J. Davis spent part of his early teens.[67] Another is the Eastern State Penitentiary in Philadelphia (John Haviland, 1823–29).[68] The Concord Penitentiary, in Concord, Massachusetts is a late example. Davis collaborated with Ithiel Town on the Gothic Revival design for the New York Orphan Asylum (1835–40), and P.B. Wight and Isaac G. Perry designed the Gothic Revival style New York State Inebriation Asylum in Binghamton, New York (1858–64).[69]

Architectural competitions frequently brought submissions in the Gothic Revival style, often from architects who offered designs in other styles at the same time. A.J. Davis submitted three designs (one Gothic Revival, two Roman) for a monument to George Washington in Richmond, Virginia.[70] A Gothic design, modeled after the Memorial to Sir Walter Scott in Edinburgh, was offered by Calvin Pollard in 1843 for a Washington Monument in New York.[71] Pollard's monument, which was designed to rise 435 feet above Union Square, was never built, and the idea of a New York monument faded with the decision to build the present one in Washington.

The competition for the Smithsonian Institution in 1846 brought

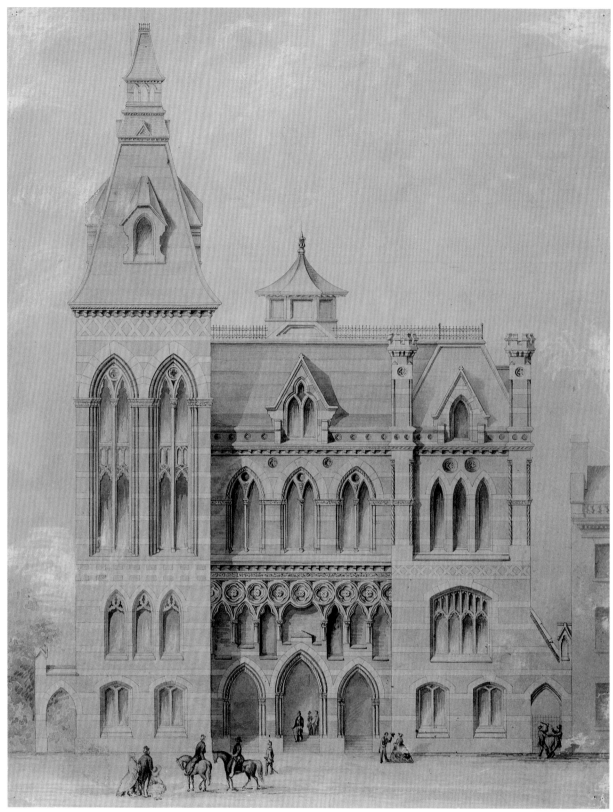

Fig. 17b. Henry Austin, *City Hall* (1861),
New Haven, Connecticut, cat. no. 44

designs by a dozen architects, all in either Gothic Revival or Romanesque style. The selection committee was chaired by Congressman Robert Dale Owen.[72] Congressman Owen was the son of the utopian social reformer Robert Owen, and he represented Indiana from the family's home in his father's utopian community, New Harmony. Like his father, the younger Owen believed strongly in the value of education for the common man. Congressman Owen believed that Joseph Smithson's bequest for "the increase and diffusion of knowledge among men" would best be executed through a free university offering education to all. Owen's view was not shared by others in Congress or on the Committee, and ultimately the view of Joseph Henry, who would become the first Secretary of the Smithsonian, favoring a scientific research center combined with a library and exhibition halls, prevailed. Even before the building committee was established, Owen and his brother, the geologist David Dale Owen, had agreed on a preliminary design for a Norman building that strongly influenced the committee's ultimate choice. They had also begun to recommend books on architectural history for the Smithsonian's library.

Robert Dale Owen's book *Hints on Public Architecture* (1849) is in part a defense of the building the committee commissioned for the Smithsonian, as well as a plea for a national style of architecture that favored Gothic as its inspiration. A Norman design by James Renwick, Jr. was chosen for the building, based on the idea that the simplicity of twelfth century Norman style would be practical and economical. Renwick had also submitted a Gothic plan, as had several others, and the competition clearly established that both medieval styles were considered suitable for museums and cultural institutions. Congressman Owen's brother, David, with the assistance of Renwick, later used a combination of Gothic and Norman styles for his Geology Laboratory in New Harmony (1859).[73] The Laboratory was dedicated to education as well as to housing Owen's collections. After David Owen's death in 1860, much of his collection went to the Smithsonian.

Although highly significant, the Smithsonian was not the first American public building built in a medieval revival style to incorporate an art gallery. The Wadsworth Atheneum in Hartford, Connecticut (1842), designed by Ithiel Town, A.J. Davis, and Henry Austin, was an important precedent (cat. no. 45, fig. 18a & 18b). Town and Davis were both involved with the American Academy of the Fine Arts in Washington, the first American art school,[74] and when the Academy failed, they were instrumental in arranging for the purchase of its collection of paintings by a group headed by Daniel Wadsworth of Hartford. Wadsworth retained the two architects to build the new paintings gallery.

Town and Davis's Wadsworth Atheneum was one of the few, if not the only, Gothic Revival museums to draw on English Gothic sources. Most later museums and academies of the fine arts that were built in a Gothic style followed Venetian models and were inspired by the writings of John Ruskin, especially *The Stones of Venice* (1851).[75] The first was the American Academy's

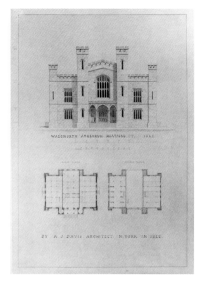

Fig. 18a. Ithiel Town, A.J. Davis, and Henry Austin, *Wadsworth Atheneum* (1842), Hartford, Connecticut, cat. no. 45

Fig. 18b. Ithiel Town, A.J. Davis, and Henry Austin, Wadsworth Atheneum (1842), Hartford, Connecticut

Fig. 19. P.B. Wight, *The Yale School of Fine Arts* (now Street Hall), New Haven, Connecticut, cat. no. 50

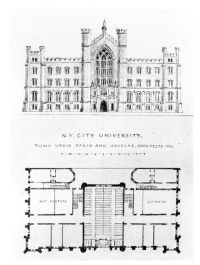

Fig. 20. Ithiel Town, A.J. Davis, & James Dakin, *Design and Plan for New York University* (1833), New York City (demolished), Metropolitan Museum of Art, Harris Brisbane Dick Fund, 1924 (24.66.1401, leaf 55)

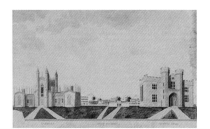

Fig. 21. Henry Austin, Yale University Library (1844) and A.J. Davis, Alumni Hall (1851–53; demolished), in a mid-19th century drawing, artist unknown, cat. no. 47

competitor and ultimate successor, the National Academy of Design in New York (1862–65). Its architect, P.B. Wight, clearly adapted his design for the National Academy from the Doge's Palace in Venice. Wight went on to design a Venetian Gothic home for the new School of Fine Arts at Yale University, donated by Augustus Street and now known as Street Hall (1866, cat. no. 50, fig. 19).[76] Other prominent art institutions designed in Venetian style include the Pennsylvania Academy of the Fine Arts, Philadelphia (1871–76), and the old Museum of Fine Arts building in Copley Square in Boston (John H. Sturgis, 1872–78).

Collegiate Gothic

One of the most familiar manifestations of the Gothic Revival style in America is found in college campuses.[77] This use of the style began during the flowering of Gothic Revival before the Civil War, and it functioned in much the same idealistic way as the use of Gothic style in domestic architecture. Much of what students and visitors see today is Gothic architecture of the late nineteenth or even the twentieth century, but as a seamless continuation of important visual and intellectual traditions it deserves to be considered here alongside its mid-nineteenth century models.

The term Collegiate Gothic is thought to have originated with A.J. Davis, whose college building and campus designs were among the pioneers in the field. James Renwick, Sr.'s Gothic plan for Columbia College, New York, of 1813, appears to be the first collegiate Gothic design to incorporate functions (library, classrooms, student rooms, kitchen) other than a chapel.[78] The central library was patterned after King's College Chapel, Cambridge (cat. no. 46), a model that would be used time and again. Renwick's plan was never executed, but in 1833 Town and Davis, working with James Dakin, designed a Gothic Revival building for another New York institution, New York University, that was erected. This building, which stood on Washington Square until 1900, included a central chapel, classrooms, library, and rooms for other functions (1835, cat. nos. 53 & 54, fig. 20).[79] Gore Hall, at Harvard University, designed by Richard Bond in 1838 and again modeled after King's College Chapel, was the first college building to be built solely as a library.[80] Yale followed suit shortly thereafter, with a library by Henry Austin (1844), likewise based on King's College Chapel (cat. no. 47, converted into Dwight Chapel in 1931 when Sterling Library was built). Davis was responsible for Yale's only other mid-century Gothic building, Alumni Hall (1851–53, cat. nos. 48 & 49, fig. 22), which stood a short distance from the library (fig. 21) and housed rooms for examinations and social events. Davis also designed a university building, again based on King's College, and extensive grounds for the University of Michigan in 1838, but the design was not executed.

Davis was responsible for the first design for an entire campus in Gothic style, that of the Virginia Military Institute in Lexington, Virginia (1848, 1850–61, cat. no. 52, figs. 23 a–c).[81] This commission came to Davis at the recommendation of Philip St. George Cocke, a wealthy Virginia planter and member of the VMI Board of Visitors, for whom Davis had

recently designed a castle-style villa, Belmead, up the James River from Richmond. The plan encompassed barracks for 200 cadets, a mess hall, classrooms, a chemical laboratory, a library, debating rooms, a separate hospital for the cadets, a porter's lodge, and several faculty houses. The consistent Gothic style throughout the campus was, and still is, striking. Much of the college was burned by Federal troops in 1864, necessitating significant rebuilding, but many of the reconstructed buildings, as well as many added later, remained consistent with Davis's original Gothic vision.

The idealism behind the choice of Gothic style for a college campus in the 1850s is revealed in the description of Bethany College, in West Virginia, by its president, William Pendleton, as cited by Paul Turner: "a literary, moral and religious school, or the union of four institutions in one — the combination of the family, the primary school, the college, and the church in one great system of education."[82] When Bethany College burned in 1857, it was rebuilt in Gothic style.

The enclosed quadrangle plan that dominated English universities such as Oxford and Cambridge did not gain a serious foothold on American campuses until the late nineteenth century, although there were hints of it in institutions such as VMI. Trinity College, Hartford, retained William Burges to design an extensive new campus based on the English quadrangle model. The plan that Burges submitted in 1874, consisting of four linked quadrangles combining Romanesque and Gothic styles, was too expensive and only a single row of its buildings was ever built. Nevertheless, the design was influential, and Yale and many other universities later adopted the quadrangle plan. To many, both inside and outside academia, the monastic connotations of the medieval quadrangle seemed appropriate to a setting where community and fellowship were valued as much as intellectual achievement and high moral tone.[83]

Ralph Adams Cram was the principal advocate of the English quadrangle design, and his designs for Princeton, starting in 1906, are typical of his work.[84] Similar was the change at Yale from the College Row facing the New Haven Green to the quadrangular enclosure that now defines the "Old Campus," essentially complete by 1900, although there have been subsequent alterations.[85] Yale's choice of a closed quadrangle for the Old Campus was as much a response to the practical problems posed by its confined position in an urban location, and the need for a barrier between the school and the city, as to the appeal of the English model.[86] Later, the quadrangle plan became synonymous with Yale's residential units, especially with the undergraduate residential "colleges." These colleges were part of a larger movement, also adopted in the "house system" at Harvard, to break the large university up into smaller community units. Beginning in 1930 with the remodeling of Harkness Quadrangle (cat. no. 51) into Branford and Saybrook Colleges, Yale constructed ten residential colleges designed by James Gamble Rogers. Six, including Branford College, are collegiate Gothic. Likewise, when the Yale Graduate School was rebuilt in the 1930s to accommodate a residential component, it was designed in Gothic style with

Fig. 22. A.J. Davis, Towers from Alumni Hall (1851–53), now part of Weir Hall, Yale University

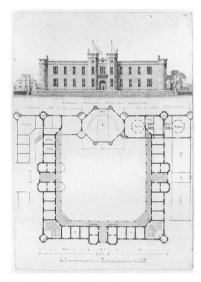

Fig. 23a. A.J. Davis, *Virginia Military Institute* (1848, 1850–61), Lexington, Virginia, cat. no. 52

Fig. 23b. A.J. Davis, Virginia Military Institute (1848, 1850–61), Lexington, Virginia

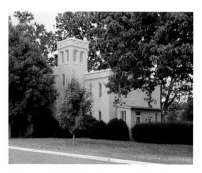

Fig. 23c. A.J. Davis, Commandant's House, Virginia Military Institute (1848, 1850–61), Lexington, Virginia

enclosed interior courtyards. The residential colleges and the Graduate School continue to serve as small communities within the larger whole, their Gothic style evoking associations with their English ancestors.

The resemblance of Yale's Sterling Memorial Library and Harvard's Memorial Hall to a cathedral, and of Yale's old library and the Yale law school to King's College Chapel in Cambridge, reflect, as Paul Turner in his history of the American college campus has shown, the continuing desire that college architecture be venerable and substantial, laden with associations that testify to an old and honored institution.[87] Even the ivy sends out "tendrils of memory and affection."[88]

Church Architecture

That Gothic Revival was the most commonly used style for new American churches in the late nineteenth and early twentieth century, even surpassing such regional styles as Spanish colonial in the Southwest and the white clapboard meeting houses of New England in popularity, is a phenomenon worth examining. The origins of Gothic Revival church architecture in America are contemporary with those of the secular American Gothic Revival movement, and some Gothic Revival churches were designed by the same architects who introduced the style to domestic architecture. At first, American Gothic Revival churches were closely based on English models. Clerics and antiquarians in Oxford and Cambridge encouraged the restoration of medieval churches and the design of new ones in their manner. These in turn inspired a growing taste for Gothic style churches in Britain that was emulated in America. English prototypes were translated to America by emigrating British architects such as Richard Upjohn and Frank Wills, and through published drawings of English Gothic and Gothic Revival churches. The Gothic Revival style spread through the works of Upjohn, Wills, and others, through books and articles on the model of Downing's domestic pattern books endorsing the style, and through the periodical of the Ecclesiological Society, a group of self-appointed architectural judges. As with Gothic Revival house architecture, designs for churches were often individualized to suit the wishes and budgets of patrons or the skills and interests of architects and builders. Ultimately, Continental European Gothic churches also served as models for the American Gothic Revival, broadening and enriching the style, and other styles of medieval church architecture were introduced as alternatives to the Gothic. Certain architects and certain Christian denominations, however, remained committed to the English Gothic style.

The reasons for the growth of Gothic Revival church architecture reflect the history of the Christian church in America. From the first, the Gothic Revival style was adopted in America primarily by Catholic and Episcopalian parishes, and since most of these were urban parishes, the first Gothic Revival churches were in cities. Baltimore, New York, Providence, Boston, and New Haven were among the cities where the first Gothic Revival churches appeared. Early designs, from the first decade of the nine-

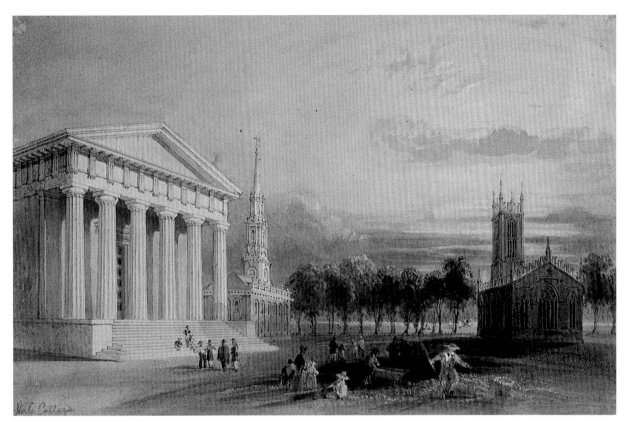

Fig. 24a. Ithiel Town, architect,
Trinity Church (1813–14), New Haven,
Connecticut (William Henry Bartlett,
The Gothic Church, New Haven,
Connecticut, before 1840, cat. no. 64)

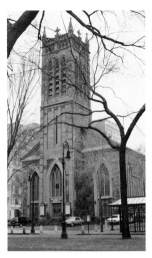

Fig. 24b. Ithiel Town, Trinity Church (1813–14), New Haven, Connecticut

teenth century, by Benjamin Latrobe, Charles Bulfinch, and others, emphasized Gothic ornament rather than plan and structure, much as had the "Gothick" architects of eighteenth-century Britain.[89] An exception was Latrobe's 1807 design for Baltimore Cathedral, which was a true revival of a medieval cruciform plan, but the design was rejected in favor of Latrobe's own Greek Revival proposal.

Part of the Anglican Church's commitment to Gothic style in England in the 1820s was an interest in fidelity to the structural and ornamental details of the Gothic prototypes. Thus true stone and brick vaults and flying buttresses were prominent features in English Gothic Revival churches. In this regard, Trinity Church on the New Haven Green (1814–16, cat. nos. 64 & 65, figs. 24a & 24b),[90] designed by Ithiel Town, was a significant advance over its American predecessors in the degree to which it reflected the British churches on which it was based. Like many of his contemporaries, Town mined a published source, in this case Gibbs's *Book of Architecture* (1728), for a model for the tower of Trinity. Dr. Timothy Dwight, Yale University's president, called it "a Gothic building, the only correct specimen it is believed in the United States."[91] Trinity Church was Town's first Gothic building, and it was designed to stand next to his own Greek Revival State Capitol and the Georgian Congregational church. Town, who was then known exclusively for his Greek Revival work, said that he chose Gothic style for Trinity "as being in some respects more appropriate, and better suited to the solemn purposes of religious worship."[92] Recognition of Trinity's importance was immediate, and it spawned generations of Episcopal parish churches in American towns and cities. Among the early examples still standing are St. Paul's Episcopal Church, Troy, New York (1826–28, a near replica of Trinity Church[93]), St. James, Arlington, Vermont (William Passman, 1829–31), and St. Luke's, Lanesboro, Massachusetts (1836, photograph, p. 86).

Other early Gothic Revival churches in America owed the inspirations for their designs to the memories and desires of American clerics who visited England. Town's design for his second major Gothic church, Christ Church Cathedral in Hartford (1827–29), was inspired by its rector, Nathaniel Wheaton, who had seen Gothic churches in England and wanted one for his parish.[94] Although based in part on Trinity, New Haven, significant differences in architectural detail point to a greater desire for fidelity and Wheaton's first-hand knowledge of English sources.

St. John's, Bangor, Maine (1836–39, photograph, p. 88), was the first Gothic Revival church of one of the most influential of Gothic Revival church architects, Richard Upjohn.[95] Upjohn probably also relied on published sources, since he already owned several books on British architecture at the time he was designing St. John's.[96]

Richard Upjohn's design for the renovation and enlargement of Trinity Church, New York (1841–46, cat. nos. 62 & 63, figs. 25a & 25b),[97] reflects one of the two most important published influences on Gothic Revival church architecture in America at this time, the drawings and writings of A.W.N. Pugin.[98] Pugin's *True Principles of Pointed or Christian*

Architecture, published in 1841, includes his drawing of an ideal church, and there is little doubt that Upjohn's final plans were directly influenced by this drawing. *True Principles* also outlined a philosophical defense of the use of Gothic style for churches. Pugin believed that buildings expressed their social roles and that their style should illustrate their purpose. Buildings should be truthful (this sounds likes Downing), the relation of structure to function should be obvious and true, ornament should be functional, and materials should be appropriate to function. In Pugin's view, Gothic was the only style that illustrated Christian spirituality.

Pugin believed in the necessity of complete fidelity to medieval sources, and this became an important tenet of the movement in mid-century. In Cambridge, a group of clerics set themselves up as the judges of historical accuracy in church design. The Cambridge Camden Society, as the group was called, disowned Pugin, a Catholic, because his designs might hint at popery, and instead went back to early English churches for their sources. The Camden Society's monthly publication, *The Ecclesiologist*, first published in 1841, rapidly came to equal Pugin's writings in influence.[99]

Fig. 25a. Richard Upjohn, Trinity Church (1841–46), interior, New York City

The Camden Society soon had a branch in the United States that endorsed the designs the Cambridge group recommended but also supported Pugin. The New York Ecclesiological Society, as this branch was called, ruled on designs submitted to it and also passed judgment on churches that were built outside its supervision.[100] Divergences from historical accuracy were severely criticized. Plans that met with their approval and were published in their journal, the *New York Ecclesiologist*, became very influential and were often copied or adapted. Churches that were praised included several designed by Frank Wills, the British architect who founded the American society and edited its journal; among them was St. Peter's, in Milford, Connecticut (1851, photograph, p. 83).[101] Also endorsed was the work of John Notman, a British contemporary of Upjohn's. Notman's St. Mark's Church in Philadelphia (1848–49, photograph, p. 92) is typical of the sorts of churches built under the aegis of the Ecclesiologists.

Richard Upjohn, on the other hand, sometimes met with criticism from the group in spite of his strongly English style, notably with his design for St. Mary's, Burlington, New Jersey (1846–48, photograph, p. 91).[102] St. Mary's is a brownstone church on a cruciform plan that depends heavily on a standing English church, St. John the Baptist, Shottesbrook, Berkshire, as recommended by the Ecclesiologists. It represents a shift in Upjohn's work away from Pugin's designs, as used in Trinity. Upjohn improved on his source rather than following it doggedly, however, and the society was not pleased. Generally, Upjohn's churches adhered quite closely to their English sources, and in spite of the bad review of St. Mary's, he remained on the Society's official list and became the premier Gothic Revival church architect in America.

Other important Upjohn churches from this period include the Church of the Ascension (1840–41, photograph, p. 89), and the Church of the Holy Communion (1846, photograph, p. 89), both Episcopal churches in New York City. The Church of the Ascension was designed at the same time as Trinity Church, but its rector, favoring the liturgical simplicity of

Fig. 26. Cambridge Camden Society, after St. Michael's Church, Longstanton, Cambridgeshire, Church of St. James-the-Less (1846–48), Philadelphia, Pennsylvania

the Low Church ritual, restrained Upjohn from using Trinity's enhanced liturgical spaces and architectural details. The resulting church is spare, but no less elegant. The Church of the Holy Communion is cited and illustrated by Robert Dale Owen in his *Hints on Public Architecture* as an outstanding example of the Decorated Gothic style.[103]

Two other church designs joined the Trinity plan in dominating Gothic Revival church architecture: St. James the Less and St. Mark's, both in Philadelphia. Both were based on English churches. St. James the Less (1846–48, fig. 26),[104] with its flat stele-like bell tower in the center of the façade, was closely based on a thirteenth century model, Long Stanton in Cambridgeshire. The design had come straight from the Cambridge Camden society—the English Ecclesiologists—as a recommendation for a country parish church. A simple, functional, and economical design, it was used for country and suburban parish churches both in England and Scotland in the mid-nineteenth century, and well into the twentieth century in America (e.g., Thompsonville, Connecticut [1846, rebuilt] and Sheffield, Massachusetts [1911, photograph, p. 86]). Upjohn used a version of it for his Calvary Church in Stonington, Connecticut (1847–49, photograph, p. 84). The design for St. Mark's, Philadelphia (John Notman, 1847–48, photograph, p. 92),[105] derived in part from the Ecclesiological Society's recommendations, drawings in this case of a church design proposed for an urban site. Adapted by Notman, who was also inspired by the newly-built St. Stephen's Westminster, London (Benjamin Ferrey, 1847), St. Mark's was influential in the development of cathedral-like urban church plans.

Richard Upjohn published a book of church designs, *Upjohn's Rural Architecture* (1852), and A.J. Downing published a "Design for a Rural Church" in the *Horticulturalist*[106] in 1848 that he had reproduced from the *Illustrated London News*. Adaptations of all of these plans, designed by local architects and builders, demonstrated the same pattern of work from published plans that resulted in the spread of the Gothic Revival villa style. Downing explained that his goal in publishing his drawing was to encourage rural parishes to build churches equivalent in "taste and meritorious design" to those that were now going up in cities. He repeatedly recommended Gothic style for country churches: "all its associations, all its history, belong so much more truly to the Christian faith."[107] Like Pugin, Downing believed that Gothic country churches conveyed "true expression." English sources for rural church design, he felt, were as valid as were English sources for his beloved villas.

A second wave of American Gothic Revival churches turned to Continental Europe for its models. James Renwick, Jr., was the premier architect of this style. Renwick's Grace Church (1846, photograph, p. 90), on Broadway and 10th Street in New York City, marks the beginning of this Continental style, and it was understood as a departure from the English Gothic by contemporary writers. Robert Dale Owen, for example, cited and illustrated it as exemplary of the European flamboyant Gothic style.[108] Grace Church has been described as combining English Perpendicular style

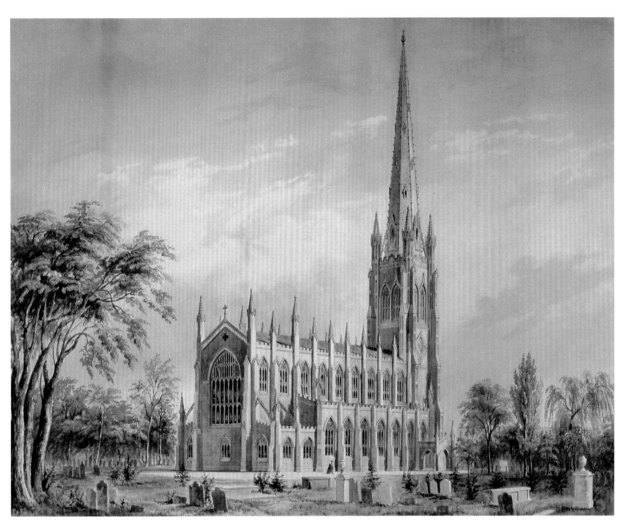

Fig. 25b. Richard Upjohn, *Trinity Church*
(1841–46), New York City, cat. no. 62

with curvilinear tracery and French gables over the doors and windows, in other words an original mixture rather than anything inspired by the stylistically pure dictates of the Ecclesiologists.[109] Grace Church was Renwick's first major work—he was only twenty-three when he won the design competition for the church—and it thus preceded his designs for the Smithsonian.

Renwick's most famous and most impressive church is St. Patrick's Cathedral (1858–79), the Roman Catholic cathedral of New York, towering over Fifth Avenue. William Pierson's extensive work on the drawings for St. Patrick's has shown that Renwick's first designs for the cathedral were based at least in part on Grace Church,[110] but that St. Patrick's was ultimately more thoroughly modelled on Continental European sources. Renwick visited Paris in 1855, with the commission for the cathedral already in hand. Restoration of Nôtre Dame by Viollet-le-Duc was underway, as was the restoration and completion of Cologne Cathedral. The cathedral in Cologne owed much to Amiens Cathedral, and in Pierson's view it is the combined Franco-German Gothic style of Cologne that was most critical to the design of St. Patrick's. The Catholic Church in New York admitted the link with Europe in its own descriptions of St. Patrick's, but it went on to claim proudly that St. Patrick's surpassed all European cathedrals. It was to stand as a monument to American architects and artisans, and to the faith of American Catholics. Americans were impressed then and apparently remain so today—St. Patrick's is as filled with visitors as any cathedral in Europe.

Conclusion

It can be argued, then, that with few exceptions the Gothic Revival style was chosen by American architects and patrons of the mid-nineteenth century because of the ideals that it was believed to express. Nowhere is this more evident than in Gothic Revival houses. Inspired by Downing's vision of Gothic Revival cottages and villas as ideally suited for a domestic life driven by intellectual and cultural aspirations, Americans who viewed themselves in this light became the primary patrons of the Gothic Revival style. Enhanced by an interest in landscape design and the picturesque, the style evolved into a uniquely American vision of domestic architecture.

Late nineteenth century Gothic Revival architecture preserved little of this intellectual, cultural, and moral content, with the exception of Collegiate and Church Gothic. As the century wore on, the Gothic Revival style declined. In domestic architecture in particular, Gothic became one of several seemingly interchangeable styles that were chosen for the sake of appearance and fashion. Gothic Revival details were combined with other revival styles in increasingly elaborate decorative schemes in which visual texture seems to have been the primary goal. Gothic often gave way to Romanesque for churches, libraries, and museums, under the influence of H.H. Richardson. Greek Revival largely reasserted itself as the popular choice for civic buildings. The Gothic Revival style of Davis, Downing, Upjohn, Renwick, and their contemporaries remains for us as a unique window onto the ideals and social history of mid-nineteenth-century America.

Notes

1 On Gothic Revival architecture in America, see primarily William H. Pierson, Jr., *American Buildings and Their Architects*, vol. 2: *Technology and the Picturesque. The Corporate and the Early Gothic Styles* (Garden City, New York, 1978; hereafter Pierson II), and vol. 3: *The Architecture of Abundance,* forthcoming (hereafter Pierson III); also Calder Loth and Julius Sadler, Jr., *The Only Proper Style. Gothic Architecture in America* (Boston, 1975; hereafter Loth and Sadler); and Margaret Henderson Floyd, "A.W.N. Pugin and the Gothic Movement in North America," in Paul Atterbury, ed., *A.W.N. Pugin: Master of Gothic Revival* (Bard Graduate Center for Studies in the Decorative Arts, and Yale University Press [New Haven and London], 1995; hereafter Floyd, "Pugin") 201–21. Works on individual architects can be found in the *Suggested Reading,* below.

2 See most recently Chris Brooks, *The Gothic Revival* (London, 1999) and Derek Churchill's essay in this volume.

3 A significant amount of Carpenter Gothic survives in New England; see Alma deC. McArdle and Deirdre Bartlett McArdle, *Carpenter Gothic: Nineteenth-Century Ornamental Houses of New England* (New York, 1978; hereafter McArdle and McArdle), although not all of the houses published there are Gothic Revival in the sense that the term is used here. The term Carpenter Gothic is problematic, since patrons and architects were often directly involved in the design of the buildings. Pierson's "folk Gothic" would be preferable; see Pierson II, 416–22.

4 A.J. Downing, *The Architecture of Country Houses* (New York, 1850, reprinted New York, 1969; hereafter Downing, *ACH*) 295, referring to the W.J. Rotch house, discussed below.

5 On Downing, see Pierson II, 349–431; George B. Tatum and Elizabeth Blair MacDougall, *Prophet with Honor: The Career of Andrew Jackson Downing, 1815–1852* (Washington, 1989); David Schuyler, *Apostle of Taste: Andrew Jackson Downing 1815–1852* (Baltimore, 1996); and Judith K. Major, *To Live in the New World: A.J. Downing and American Landscape Gardening* (Cambridge, Mass., 1997).

6 On Davis, see Pierson II, 270–348; and Amelia Peck, ed., with an Introduction by Jane B. Davies, *Alexander Jackson Davis, American Architect 1803–1892* (New York, 1992; hereafter Peck, *Davis*).

7 Alexander Jackson Davis, *Rural Residences* (New York, 1837) 3, as cited by Davies in Peck, *Davis* 14.

8 The first systematic attempt to differentiate styles of Gothic architecture and arrange them chronologically, Rickman's work remains the basis for the terminology used today.

9 As Ithiel Town's partner, Davis had access to what was probably the best privately owned architectural library in America. Continental sources for Gothic domestic architecture were fewer, since aside from the Maison de Jacques Coeur in Bourges, little important Gothic domestic architecture survived there. A.W.N. Pugin's writings are discussed by Derek Churchill in his essay in this volume.

10 Loudon's encyclopedia of designs was particularly influential on American architects; on Loudon in Britain, see, e.g., John Gloag, *Mr. Loudon's England: The Life and Work of John Claudius Loudon, and His Influence on Architecture and Furniture Design* (Newcastle-on-Tyne, 1970); Elizabeth B. MacDougall ed., *John Claudius Loudon and the Early Nineteenth Century in Great Britain* (Washington, 1980); and Melanie Louise Simo, *Loudon and the Landscape: From Country Seat to Metropolis* (New Haven, 1988).

11 Davies, in Peck, *Davis* 14, from *Rural Residences.*

12 Downing, *ACH* 28.

13 Downing, *ACH* 29.

14 Pierson II, 292–95, 298–300; Peck, *Davis* 70–71, colorplate 42.

15 For an excellent overview of the history, architecture, and gardens of Lyndhurst, see Amelia Peck, *Lyndhurst: A Guide to the House and the Landscape* (Tarrytown, 1998). Pierson II, 308–48, provides a thoughtful and perceptive analysis of the building and its place in architectural history.

16 The term "cottage-villa" is Downing's. He uses it, e.g., for the Rotch House in New Bedford (a Davis design), which he calls a "Cottage-Villa in the Rural Gothic Style" (*ACH* 295). Downing also refers to this house as both a cottage (297) and a villa (295). Size and the number of servants it took to run the household seem to be the determining factors in Downing's definition of cottage vs. villa, but he uses the two terms more or less interchangeably in the chapter on villas and country houses in this book. He also uses the phrase "villas built in cottage style" (40) to describe larger homes designed in the form of cottages. Modern scholars often prefer the term "cottage" for Davis's designs; see the discussion in Pierson II, 389–92.

17 As cited in Peck, *Davis* 73, n. 26.

18 Harrel House: Pierson II, 362–65; Kenwood: Peck, *Davis* 73, colorplate 15. For others, see Peck, *Davis* 77. Many of the same elements are introduced in the villa Davis designed for Robert Donaldson, in Fishkill Landing, New York; see Peck, *Davis* 72, colorplate 43; Pierson II, 300–304.

19 Downing, *ACH* 47, 119–20, 260.

20 Pierson II, 332.

21 Peck, *Davis* 76–77, colorplate 49.

22 An interesting introduction to them can be found on a website called "American Castles," at www.dupontcastle.com/castles.

23 See Harold Hornstein, "The 'Squire of Hallock's Castle' was Journalism Giant," *The New Haven Register* Sunday, February 5, 1978, page B12.

24 See Everard M. Upjohn, *Richard Upjohn. Architect and Churchman* (New York, 1939; hereafter Upjohn) 38–43, figs. 5–7. His later houses, built after he became primarily a Gothic Revival church architect, were Italianate, preserving an important distinction between the styles of sacred and secular buildings; I am grateful to William Pierson for this point.

25 Randall Stewart, ed., *The American Notebooks*, July 11, 1837, p. 8, as cited by Upjohn 39.

26 McArdle and McArdle 88–92; Megan Aldrich, *Gothic Revival* (London, 1994) 123; not listed in Upjohn.

27 Downing, *ACH* 263; for a "man of ambition and imagination," however, towers and campaniles were acceptable.

28 Downing, *ACH* 262.

29 Downing, *ACH* 274. Like many of his contemporaries, e.g., Robert Dale Owen, *Hints on Public Architecture* (New York, 1849) 6–10, Downing (*ACH* 264) hoped that America would develop its own architectural style. Owen's volume is best known for its discussion of the Smithsonian Institution, but it is an important contemporary source for architectural theory in nineteenth-century America; I am grateful to J.J. Pollitt for bringing this book to my attention.

30 Downing, *ACH* 354.

31 Downing, *ACH* 257–59. Downing was speaking here for many who advocated country retreats for the cultivation of the mind, the so-called villa movement; it has recently been suggested that Henry David Thoreau's sojourn at Walden Pond was part of this movement (W. Barksdale Maynard, "Thoreau's House at Walden," *Art Bulletin* 81, no. 2 [June 1999] 303–25), although if so he clearly did more with it than most.

32 I have benefited greatly from discussions with William Pierson on these ideas.

33 Downing, *ACH* 259. I have learned much from William Pierson's unpublished lecture on this subject delivered at the Metropolitan Museum of Art in 1987, which he kindly shared with me; a version of the lecture was given in April 2000 at the opening of the *Modern Gothic* exhibition at Yale.

34 Downing, *ACH* 30–38.

35 Downing, *ACH* 198–203. Downing is again going back to British sources here, specifically Wordsworth, Spenser and Sir Joshua Reynolds, all of whom he cites.

36 Downing, *ACH* 206–11.

37 On New Bedford, see Judith Boss, *New Bedford: A Pictorial History* (Norfolk, 1983).

38 Downing, *ACH* 295–98.

39 Downing, *ACH* 295.

40 Information on Charles Green is drawn from an unpublished biography compiled by Sarah Starr Nichols, a descendant of Commodore Green, from family letters. Nichols's biography is on file at the Wood Memorial Library, South Windsor, Connecticut. I am grateful to the librarians at the Wood Library for their kind assistance.

41 For more, see Peck, *Davis* 19 and list, from which my information is drawn.

42 The drawing is preserved in the Avery Architectural Library, Columbia University.

43 The Fowler House is closest to Downing, *ACH* design XXIX; see R.M. Taylor, et al, *Indiana: A New Historical Guide* (Indianapolis, 1998) 492–93. I am grateful to Leslie Preston Day for bringing this volume and thus this house to my attention. See also Robert C. Kriebel, *The House that Moses Fowler Built* (Lafayette, 1985).

44 McArdle and McArdle 66–68; on Morrill, see Coy F. Cross, *Justin Smith Morrill: Father of the Land Grant Colleges* (East Lansing, 1999).

45 On the house and its owner, see Nancy Curtis, *Roseland Cottage* (Boston, SPNEA, n.d.); Wells's drawings for the house are in the SPNEA collection. Wells also designed the Jonathan Sturges House in Fairfield, Connecticut (photograph p. 83).

46 Downing, *ACH* 442–43, figs. 263–70.

47 This important commission and the reasons for it are admirably presented by Pierson in his forthcoming third volume of *American Buildings and Their Architects: The Architecture of Abundance*, chapter 3. I am indebted to Professor Pierson for sharing several chapters of his book with me in manuscript.

48 Downing, *ACH* 365.

49 Pierson II, figs. 239–41 (Kingscote) and figs. 260–62 (Rotch House).

50 Downing, *ACH* 386, cf. fig. 181, interior designed by Davis.

51 Green-Meldrim House, John S. Norris, architect: Pierson II, 378–81, figs. 242–46; some Gothic ornament is included in the drawing room. I thank Professor Pierson for bringing these two houses to my attention.

52 *ACH* 259, with reference to villas; Downing (107) recommends a bookcase built into the wall for the parlor of a cottage. For a Gothic corner bookcase design, see *ACH* 444, fig. 272.

53 For a photograph of the house, built for Charles Dibble and attributed to two local carpenters, Messrs. Busey and Herald, see Sadler & Loth 104.

54 On Llewellyn Park, see Jane B. Davies, "Llewellyn Park in West Orange, New Jersey," *Antiques* 107 (January, 1975) 142–58; Richard Guy Wilson, "Idealism and the Origin of the First American Suburb, Llewellyn Park, New Jersey," *American Art Journal* 11 (October, 1979) 79–90; and Susan Henderson, "Llewellyn Park, Suburban Idyll," *Journal of Garden History* 7, no. 3 (July–September, 1987) 221–43. At least part of Llewellyn Park is

now a "gated community" not open to the public; according to Henderson, other parts of it have been altered or have not survived.

55 Haskell's interest in Fourier's "perfectionism" is discussed by Henderson 239–40.

56 Henderson 243, n. 43.

57 In Peck, *Davis* 105–19.

58 Loth and Sadler 27.

59 On Dakin, see Arthur Scully, Jr., *James Dakin, Architect: His Career in New York and the South* (Baton Rouge, 1973); on the Capitol Building, pp. 126–61.

60 Loth and Sadler 85.

61 Samuel Clemens, *Life on the Mississippi* (New York, 1883, reprinted in Guy Cardwell, ed., *Mark Twain: Mississippi Writings* (New York, 1982) 468. The entire chapter, "Castles and Culture," focuses on the Southern attachment to medieval romanticism.

62 See the excellent discussion of Davis's civic designs by Francis R. Kowsky in Peck, *Davis* 40–57.

63 On the influence of Pugin on American Gothic Revival architecture, see Floyd, "Pugin."

64 Owen 65–66; he cites the Maison de Jacques Coeur in Bourges as exemplary in style.

65 Peck, *Davis* 108.

66 Illustrated by Loth and Sadler 130–31.

67 Davies, in *Peck*, Davis 14.

68 Loth and Sadler 44.

69 Sarah Bradford Landau, *P.B. Wight: Architect, Contractor, and Critic, 1838–1925* (Chicago, 1981) 13, fig 3.

70 Peck, *Davis* 114.

71 Loth and Sadler 84–85.

72 The definitive biography of Owen is Richard William Leopold, *Robert Dale Owen: A Biography* (Cambridge, Mass. 1940). Controversy surrounded the selection procedures; for this and a discussion of the various entries, some of which are preserved in the Smithsonian Archives, see the introduction by Cynthia Field to the reprint edition of *Hints on Public Architecture*, published by the Smithsonian in 1978; Loth and Sadler 68–70; and Pierson III, chapter 4 (forthcoming).

73 On the Owen Laboratory, the fourth that he built in New Harmony, see Taylor et al. (n. 43) 249–50. The building is now a private residence.

74 See the excellent discussion of the American and National Academies and Town's and Davis's roles in them, in Peck, *Davis* 25–39.

75 See the discussion in Loth and Sadler 112–17.

76 On Wight, see Landau (n. 69). I am grateful to Victoria Solan for her extensive research on Street Hall and related issues. See also our forthcoming article on Street Hall in the *Yale University Art Gallery Bulletin*.

77 On the history of the college campus, see Paul V. Turner, *Campus: An American Planning Tradition* (Cambridge Mass., 1995; hereafter Turner, *Campus*), especially, on Gothic, 110–26.

78 Turner, *Campus* 110, figs. 110–11.

79 Turner, *Campus* 123–24, fig. 126. A Greek Revival design submitted by Davis for the same project was rejected; see ibid, fig. 125; and Peck, *Davis* pl. 30.

80 Turner, *Campus* fig. 115.

81 Turner, *Campus* 124–25; Peck, *Davis*, 49–50, fig. 2.16; Roster Lyle, Jr., "The Architecture of VMI," in Thomas W. Davis, *A Crowd of Honorable Youths* (Lexington, Virginia, 1988) 105–21.

82 Turner, *Campus* 117.

83 Turner, *Campus* chapter 6, especially p. 216.

84 On Cram's work at Princeton, see Turner, *Campus* 230–33.

85 See the plans in Turner, *Campus* figs. 218–19.

86 Turner, *Campus* 217, citing the writings of Noah Porter, then Yale's president, on this subject.

87 Turner, *Campus* 117.

88 Ruskin, as quoted in Turner, *Campus* 120.

89 For a good survey, see Pierson II, 113–24, and Loth and Sadler 29–35.

90 Pierson II, 129–34.

91 As quoted by Loth and Sadler 39.

92 As quoted by Pierson II, 132, and Loth and Sadler 38–39.

93 Pierson II, 139–44, figs. 98–104.

94 On Christ Church Cathedral, see Pierson II, 285–86; Wheaton's role, noted by Pierson, is supported by unpublished research by Anstress Farwell, which was brought to my attention by E.M. Brown.

95 On Trinity's influence, see Pierson II, 136–48; on St. James, 144–46, fig. 105; on St. Luke's, 146–48, fig. 106; on St. John's, Pierson II, 159–61, fig. 109, and Upjohn 44–46, figs. 9–10.

96 Town: Pierson II, 130, and n. 3.43. Upjohn: Stanton (infra n. 100) 60.

97 Upjohn 47–67; Pierson II, 159–72.

98 On this influence in general, see Floyd, "Pugin" and Pierson II, 154–58; on Pugin's influence on Upjohn's designs for Trinity, Pierson II, 163–67.

99 On both Pugin and the Cambridge Camden Society, see Derek Churchill's essay in this volume, with references.

100 On the Society and its role and other major issues relating to American Gothic style church architecture of the mid-nineteenth century, see Phoebe B. Stanton, *The Gothic Revival and American Church Architecture. An Episode in Taste 1840–1856* (Baltimore, 1968, 2nd ed. 1997; hereafter Stanton), on which I have relied here, and Pierson II, 149–205.

101 Stanton 185, fig. V–2; on Wills, passim. See also Wills's own book, *Ancient English Ecclesiastical Architecture and its Principles Applied to the Wants of the Church of the Present Day* (New York, 1850).

102 Upjohn 88–90, figs. 37–38; Stanton 73–83, figs. II-23, II-27 – III-30; Pierson II, 177–84, figs. 117–22.

103 P. 71, illustrated opposite p. 63 in a lithograph that shows it in a landscape rather than its present urban setting. Everard Upjohn (Upjohn 87) stated that this lithograph represented the church's original setting, but Owen specifically states (p. 71, n.) that the landscape was introduced by the artist in place of the actual city streets (6th Avenue and 20th Street).

104 Stanton 91–115, figs. III-5 – III-8.

105 Stanton 115–25, figs. III-9 – III-13.

106 Stanton 312.

107 Quoted by Stanton 313.

108 *Hints on Public Architecture* 56, 71, illustrated p. 56 (interior), and opposite page 92 (exterior). See also Pierson II, 215–16, fig. 139.

109 Pierson II, 216.

110 On St. Patrick's, see the fundamental discussion by Pierson II, 220–69, on which the following is based.

Checklist
of the
Exhibition

1

Introduction

1. Horace Walpole
(British, 1717–97) and Richard
Bentley (British, 1708–82)
*Pair of Side Chairs from Strawberry
Hill* (1755)
Ebonized beechwood, modern
upholstery
Each H. 133; W. 60.3; D. 54 cm
Lent by the Lewis Walpole Library,
Yale University

2. Paul Sandby
(British, 1725–1809)
*View of Strawberry Hill from the
Southeast* (ca. 1783)
Watercolor on paper
13.7 x 18.9 cm
Lent by the Lewis Walpole Library,
Yale University

3. William Kent
(British, ca. 1685–1748)
*Design for a Gothic Umbrella
Temple* (ca. 1730s)
Pen and ink on paper
35.4 x 19.6 cm
Lent by the Yale Center for British Art,
Paul Mellon Collection (B1975.2.360)

4. John Wootton
(British, ?1682–1764)
*Riders Pausing by the Ruins of
Rievaulx Abbey* (ca. 1740–50)
Oil on canvas
55.7 x 55.7 cm
Lent by the Yale Center for British Art,
Paul Mellon Collection (B1981.25.700)

5. Samuel Palmer
(British, 1805–81)
Tintern Abbey (1835)
Watercolor, ink, and graphite
on paper
26.2 x 37.2 cm
Lent by the Yale Center for British Art,
Paul Mellon Collection (B1977.14.4102)

6. Thomas Cole
(American, born in England,
1801–48)
The Vesper Hymn (ca. 1838)
Oil on canvas
54.6 x 45.1 cm
Yale University Art Gallery, Gift of the
Associates in Fine Arts (1949.41)

*Domestic Architecture and
Furnishings: Architecture*

7. Sir Jeffry Wyatville
(British, 1766–1840), studio
Windsor Castle, south elevation
(ca. 1830)
Watercolor on paper
Image only: 8.6 x 25.5 cm
Lent by the Yale Center for British Art,
Paul Mellon Collection (B1975.2.130)

8. Sir Jeffry Wyatville
(British, 1766–1840), studio
Windsor Castle, north elevation
(ca. 1830)
Watercolor on paper
Image only: 8.6 x 25.5 cm
Lent by the Yale Center for British Art,
Paul Mellon Collection (B1975.2.131)

9. James Wyatt
(British, 1746–1813) and
Joseph Mallord William Turner
(British, 1775–1851)
*Projected Design for Fonthill Abbey,
Wiltshire* (1798)
Watercolor on paper
67 x 105.4 cm
Lent by the Yale Center for British Art,
Paul Mellon Collection (B1975.4.1880)

10. Alexander Jackson Davis
(American, 1803–92)
Knoll, Tarrytown, New York, south
and east (front) elevations (1838)
Watercolor and ink on paper
36.2 x 26.0 cm
Lent by the Metropolitan Museum of
Art, Harris Brisbane Dick Fund, 1924
(24.66.70)

11. Alexander Jackson Davis
(American, 1803–92)
Lyndhurst, Tarrytown, New York,
west (rear) elevation and plan (1865)
Watercolor, ink, and graphite on paper
47.9 x 67.6 cm
Lent by the Metropolitan Museum of
Art, Harris Brisbane Dick Fund, 1924
(24.66.14)

12. Alexander Jackson Davis
(American, 1803–92)
Walnut Wood, Bridgeport,
Connecticut (1846–50)
Watercolor and ink on paper
36.5 x 50.8 cm
Lent by Drawings and Archives, Avery
Architectural and Fine Arts Library,
Columbia University (1940.001.00038)

13. Unknown, American
(ca. 1836–85)
Hallock House, New Haven,
Connecticut
(architect: Sidney M. Stone, 1836)
Oil on canvas
83.8 x 140.3 cm
Lent by the New Haven Colony
Historical Society (1971.63)

14. Richard Upjohn
(American, 1802–78)
Kingscote, Newport, Rhode Island,
two elevations (1839)
Watercolor and ink on paper
8.4 x 15.6 cm (.00762);
8.5 x 12.0 cm (.00763)
Lent by Drawings and Archives, Avery
Architectural and Fine Arts Library,
Columbia University (1000.011.00762
and 1000.011.00763)

15. Alexander Jackson Davis
(American, 1803–92)
House for William J. Rotch,
New Bedford, Massachusetts (1845)
Watercolor, ink, and graphite on paper
41.9 x 65.4 cm
Lent by the Metropolitan Museum of
Art, Harris Brisbane Dick Fund, 1924
(24.66.20)

16. Henry Austin
(American, 1804–91)
Design and Plan for a Gothic House
Watercolor and graphite on paper
Each 33.3 x 40.5 cm
Lent by Manuscripts and Archives,
Sterling Memorial Library, Yale
University

*Domestic Architecture and
Furnishings: Interiors and Furnishings*

17. Alexander Jackson Davis
(American, 1803–92)
Knoll, Dining Room, perspective
(ca. 1840)
Watercolor, ink, and graphite on paper
47.9 x 67.6 cm
Lent by the Metropolitan Museum of
Art, Harris Brisbane Dick Fund, 1924
(24.66.867)

18. Alexander Jackson Davis
(American, 1803–92)
*Design for Tables and Chairs
for Knoll*
Graphite on paper
11 x 16.8 cm
Lent by Drawings and Archives, Avery
Architectural and Fine Arts Library,
Columbia University (1940.001.00441)

19. Alexander Jackson Davis
(American, 1803–92)
Design for an Interior
Ink on paper
7 x 9.4 cm
Lent by Drawings and Archives, Avery
Architectural and Fine Arts Library,
Columbia University (1940.001.00460)

20. Alexander Jackson Davis
(American, 1803–92)
Designs for Gothic Furniture
Watercolor and ink on paper
15.8 x 20.5 cm
Lent by Drawings and Archives, Avery
Architectural and Fine Arts Library,
Columbia University (1940.001.00424)

21. John (1801–75) &
Joseph W. (1806–78) Meeks
(American, New York)
Desk and Bookcase (1836–ca. 1855)
American black walnut, walnut veneer;
interior mostly satinwood
H. 235.1; W. 135.6; D. 61.1 cm
Yale University Art Gallery, University
Purchase (1971.70)

22. American, maker unknown
(19th century)
Looking Glass
H. 80.5; W. 41.9; D. 3.0 cm
Gilded wood and glass
Lent by Stephen Parks

5

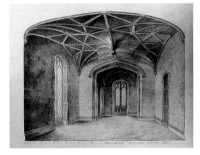

17

28

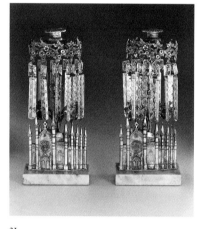

31

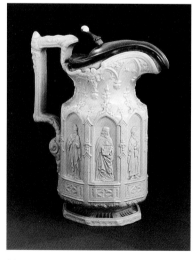

34

23. American, maker unknown
(19th century)
Side Chair
Ebonized wood, modern upholstery
H. 115; W. 46.0; D. 46.0 cm
Lent by Stephen Parks

24. American, maker unknown
(19th century)
Pair of Side Chairs (ca. 1850)
Mahogany
Each H. 112.1; W. 35.6; D. 46 cm
Yale University Art Gallery,
Gift of Mr. and Mrs. Alexander O. Vietor
(1973.83.1–2)

25. American, maker unknown
(19th century)
Pair of Andirons (ca. 1830)
Brass and iron
H. 33.5; W. 24.5; D. 45.7 cm
Yale University Art Gallery, S. Sidney
Kahn, B.A. 1959, Fund (1980.72a–b)

26. British, maker unknown
(12th–13th century)
Encaustic Floor Tile
Glazed red earthenware
H. 16.2; W. 16.3; D. 3.5 cm
Lent by Stephen Parks

27. Minton & Co.,
Stoke-on-Trent
(British, 1817–present)
Encaustic Floor Tile (ca. 1850)
Glazed red earthenware
H. 14.9; W. 15; D. 2.5 cm
Lent by Stephen Parks

28. A.W.N. Pugin
(British, 1812–52) and
E.W. Pugin, (British, 1834–75)
designers; manufactured by
Minton & Co., Stoke-on-Trent
(British, 1817–present)
Encaustic Floor Tile with King
(1843–56)
Red earthenware with yellow slip inlay
H. 16.2; W. 16; D. 2.5 cm.
Private Collection

29. Design attributed to
Christopher Dresser
(British, 1834–1904); manufactured
by Minton & Co., Stoke-on-Trent
(British, 1817–present)
Floor Tile with Gothic Spiral
(designed 1871, manufactured
ca. 1875)
Lead-glazed red earthenware with under-
glaze transfer-printed decoration
15.3 x 15.1 cm
Private Collection

30. A.W.N. Pugin
(British, 1812–52)
Wallpaper (designed for Magdalen
College, Oxford, ca. 1850; sample
printed from original blocks,
ca. 1995)
Paper
73.0 x 53.4 cm
Lent by Stephen Parks

31. William F. Shaw
(American, 1820–1900)
*Pair of Girandoles with Bigelow
Chapel*
Crystal, brass
Each 36.2 x 16.0 x 8.2 cm
Lent by Stephen Parks

32. A.W.N. Pugin
(British, 1812–52); manufactured by
Minton & Co., Stoke-on-Trent
(British, 1817–present)
Dinner Plate, "Gothic" Pattern
(ca. 1844, 1857)
Hand painted porcelain
H. 3.3; Diam. 27.0 cm
Lent by Stephen Parks

33. A.W.N. Pugin
(British, 1812–52); manufactured
by Minton & Co., Stoke-on-Trent
(British, 1817–present)
*Motto Plate ("It is a good tongue
that says no ill and a better heart
that thinks none.")* (ca. 1852)
Earthenware, color-printed motto
decoration
H. 2.5; Diam. 26.4 cm
Lent by Stephen Parks

34. Charles Meigh
(British, Hanley, 1835–47)
Apostle Jug (patented 1842)
Molded stoneware
H. 23.5; Diam. 11.5; W. 20 cm.
Lent by Stephen Parks

35. Sandwich Glass Company
(American, 1825–88)
Sugar Bowl (1830–50)
Pressed glass
H. 13.4, Diam. 13 cm
Yale University Art Gallery, Gift of Mrs.
Lewis Fox Frissel. Lewis Fox Frissel,
B.A. 1895, Collection of Sandwich Glass
(1940.424)

36. Henry Wilkinson & Company
(British, Sheffield, 1828–71)
Mustard Pot (1837)
Silver and glass
H. 9.0; Diam. 6.5; W. 9.5 cm
Lent by Stephen Parks

37. Elkington & Company
(British, Birmingham,
1840–present)
Toast Rack (ca. 1842–49)
Electroplated base metal
H. 17.0; L. 16.5; W. 11.5 cm
Lent by Stephen Parks

38. William Forbes
(American, born 1799; active
1826–64); retailed by Ball
Tompkins and Black
(in partnership 1839–51)
Child's Mug, engraved
"For my Nephew" (1839–51)
Sterling silver
H. 9.6; Diam. 7.4; W. 9.5 cm
Private Collection

39. American, maker unknown
(19th century)
Two Tablespoons (ca. 1847)
Sterling silver
L. 21.6 cm
Yale University Art Gallery,
Gift of Robert Nesheim (1985.101.1.1–2)

40. William Gale and Son
(American, ca. 1850–66)
Dinner Fork (patented 1847,
manufactured 1847–66)
Sterling silver
L. 19.7 cm.
Yale University Art Gallery,
Gift of Mr. Stephen Parks (1973.44)

Civic Architecture

41. Sir Charles Barry
(British, 1795–1860)
*Perspective View of the New Houses
of Parliament* (ca. 1840s)
Watercolor, body color, and ink on paper
40.2 x 76.6 cm
Lent by the Yale Center for British Art,
Paul Mellon Collection (B1975.4.1882)

42. Richard Michell Upjohn
(American, 1827–1903)
*Connecticut State Capitol, Hartford,
Connecticut*, elevation (1875)
Graphite on paper
36 x 42.5 cm
Lent by Drawings and Archives, Avery
Architectural and Fine Arts Library,
Columbia University (1000.011.00300)

43. Richard Michell Upjohn
(American, 1827–1903)
*Connecticut State Capitol, Hartford,
Connecticut*, interior (1875)
Graphite on paper
47.2 x 31.1 cm
Lent by Drawings and Archives, Avery
Architectural and Fine Arts Library,
Columbia University (1000.011.00303)

44. Henry Austin
(American, 1804–91)
City Hall, New Haven, Connecticut,
façade (1861)
Watercolor and ink on paper
48.8 x 38.8 cm
Lent by the Whitney Library of the
New Haven Colony Historical Society
(MSS #AD7)

45. Ithiel Town
(American, 1784–1844), Alexander
Jackson Davis (American,
1803–92), and Henry Austin
(American, 1804–91)
*Wadsworth Atheneum, Hartford,
Connecticut* (1842)
Watercolor, ink, and graphite on paper
36.7 x 25.4 cm
Lent by The Metropolitan Museum
of Art, Harris Brisbane Dick Fund, 1924
(24.66.866)

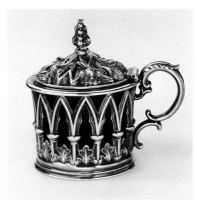

36

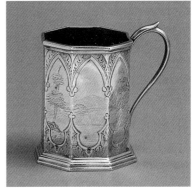

38

73

Collegiate Gothic

46. Thomas Malton, Jr.
(British, 1748–1801)
*King's College, the Chapel and
Clare Hall in the University of
Cambridge* (1799)
Hand colored aquatint
39.9 x 52.9 cm
Lent by the Yale Center for British Art,
Paul Mellon Collection (B1977.14.11896)

47. American, artist unknown
(mid-19th century)
*View of Yale College, Library and
Alumni Hall* (after 1853)
Pen and ink and watercolor on paper
37.5 x 59.6 cm
Lent by Manuscripts and Archives,
Sterling Memorial Library,
Yale University

48. Alexander Jackson Davis
(American, 1803–92)
*Three Working Drawings for
Alumni Hall, Yale University*
(1852–53)
Watercolor and pen and ink on paper
53.3 x 45 cm; 35.5 x 43.2 cm; 35.3 x 42.2 cm
Lent by Manuscripts and Archives,
Sterling Memorial Library, Yale
University (YR646 RUI; series I)

49. Alexander Jackson Davis
(American, 1803–92)
*Design for Alterations to
Alumni Hall, Yale University*
(1881; not executed)
Watercolor, ink, and graphite on paper
35.6 x 53.6 cm
Lent by the Metropolitan Museum of
Art, Harris Brisbane Dick Fund, 1924
(24.66.19)

50. Peter Bonnett Wight
(American, 1838–1925)
Design for the Yale School of Fine Arts
(1864, building completed 1867)
Pen and ink and wash on paper
44.8 x 66.0 cm
Yale University Art Gallery, Everett V.
Meeks, B.A. 1901, Fund (1999.44.3)

51. James Gamble Rogers
(American, 1867–1947)
*Preliminary Model for Harkness
Tower and Memorial Quadrangle*
(ca. 1917)
Plaster
H. 147.3; W. 121.9; D. 40.6 cm
Lent by Branford College,
Yale University

52. Alexander Jackson Davis
(American, 1803–92)
Virginia Military Institute,
Lexington, Virginia
(campus design 1848, 1850–61)
Watercolor, ink, and graphite on paper
36.2 x 26.4 cm
Lent by the Metropolitan Museum of
Art, Harris Brisbane Dick Fund, 1924
(24.66.1403[21])

53. Alexander Jackson Davis
(American, 1803–92)
New York University Chapel,
Washington Square, New York,
interior (1833–37)
Watercolor, ink, and graphite on paper
66.0 x 48.9 cm
Lent by the New York Historical Society,
A.J. Davis Collection (15)

54. Alexander Jackson Davis
(American, 1803–92)
*Two Lion Head Gargoyles, New York
University Chapel*, New York
(ca. 1837, demolished 1876)
Plaster with traces of polychrome
Each 17.8 x 17.8 x 7.6 cm
Lent by Drawings and Archives,
Avery Architectural and Fine Arts
Library, Columbia University

48

Church Architecture, Sculpture, and Furnishings: Architecture

55. Edouard-Denis Baldus
(French, 1820–82)
Façade of Notre Dame de Paris
(19th century)
Photograph, albumen print
60.5 x 47 cm
Yale University Art Gallery, Stephen
Carlton Clark, B.A. 1903, Fund
(1977.118.1)

56. Charles Meryon
(French, 1821–68)
The Apse of Notre Dame de Paris
(1854)
Etching
16.4 x 29.6 cm
Yale University Art Gallery,
Gift of "A Lover of Prints" (1928.346)

57. A.W.N. Pugin
(British, 1812–52)
North Transept of Amiens Cathedral
Graphite on paper
26 x 17 cm
Lent by The James M. and Marie-Louise
Osborn Collection, Beinecke Rare Book
and Manuscript Library, Yale University
(Osborn 95.3.3 [115.1])

58. A.W.N. Pugin
(British, 1812–52)
*Interior of the North Aisle of St.
Patrice, Rouen*
Watercolor on paper
17.8 x 10.5 cm
Lent by The James M. and Marie-Louise
Osborn Collection, Beinecke Rare Book
and Manuscript Library, Yale University
(Osborn 95.3.3 [133])

59. A.W.N. Pugin
(British, 1812–52)
*Exterior Design for Dudley
Church* (1838)
Watercolor and ink on paper
34 x 24.2 cm
Lent by the Yale Center for British Art,
Paul Mellon Collection (B1975.2.180)

60. A.W.N. Pugin
(British, 1812–52)
*Interior Design for Dudley
Church* (1838)
Watercolor and ink on paper
31.2 x 18.9 cm
Lent by the Yale Center for British Art,
Paul Mellon Collection (B1975.2.179)

61. George Edmund Street
(British, 1824–81)
*Perspective of a Church Interior with
Polychrome Decoration* (ca. 1850s)
Watercolor and ink over graphite
on paper
30.5 x 29.4 cm
Lent by the Yale Center for British Art,
Paul Mellon Collection (B1975.2.383)

62. Richard Upjohn
(American, 1802–78)
Trinity Church, New York City,
elevation (1840–46)
Watercolor and ink on paper
49.7 x 63.8 cm
Lent by Drawings and Archives, Avery
Architectural and Fine Arts Library,
Columbia University (1000.011.01098)

63. Richard Upjohn
(American, 1802–78)
Trinity Church, New York City,
interior (1840–46)
Watercolor on paper
54.8 x 37.8 cm
Lent by Drawings and Archives, Avery
Architectural and Fine Arts Library,
Columbia University (1000.011.01084)

64. William Henry Bartlett
(American, 1809–54)
*Study for Bartlett's Engraving
"The Gothic Church, New Haven,
Connecticut"* (before 1840; Ithiel
Town, architect, 1813–14)
Watercolor, graphite, and gouache
on paper
22.2 x 34.2 cm
Yale University Art Gallery, Gift of the
Reverend Anson Phelps Stokes, B.A. 1896,
M.A. (Hon.) 1900, L.L.D. 1921
(1929.779.34)

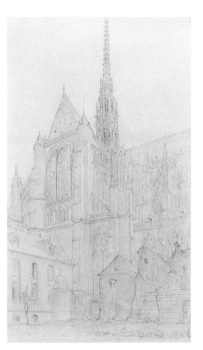

57

65. Amos P. Doolittle
(American, 1754–1832)
Trinity Church, New Haven
Engraving
9.4 x 6.4 cm (plate)
Yale University Art Gallery, Anonymous
Gift in Honor of Elizabeth Chase,
1999.119.1

66. Rufus G. Russell
(American, 1823–96)
*Calvary (Second) Baptist Church,
New Haven, Connecticut*
Watercolor and ink on paper
42 x 29 cm
Lent by the Whitney Library of the New
Haven Colony Historical Society (94)

67. Richard Upjohn
(American, 1802–78)
*St, James's Church, New London,
Connecticut* (1851)
Watercolor and ink on paper
41 x 49 cm
Lent by Drawings and Archives, Avery
Architectural and Fine Arts Library,
Columbia University (1000.011.00692)

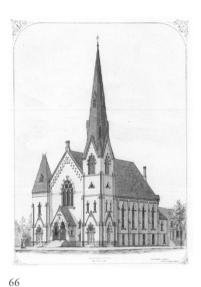

66

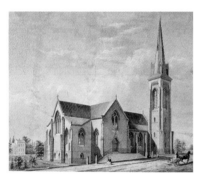

67

*Church Architecture, Sculpture, and
Furnishings: Sculpture*

68. French, artist unknown
(middle of the 12th century)
*Fragmentary Capital from the
Church of Saint-Etienne at Dreux,
with seated figure of King Herod*
Limestone
H. 55.9; W. 21.6; 19.0 cm
Yale University Art Gallery, University
Purchase, through Professor Crosby
(1938.103)

69. French, Languedoc,
artist unknown
(early 13th century)
Capital with Animal Ornament
Limestone
H. 26; W. 24.2; D. 23 cm
Yale University Art Gallery, Bequest of
Maitland F. Griggs, B.A. 1896 (1943.283)

70. British, artist unknown
(15th century)
St. John the Baptist (ca. 1460)
Oak
H. 65.4; W. 18.4; D. 16.2 cm
Yale University Art Gallery, Maitland F.
Griggs, B.A. 1896, Fund (1958.69)

71. German, Southern Rhine,
artist unknown
(15th century)
*Virgin and Child (Schöne
Madonna)*
Poplar with renewed polychromy
H. 148.0; W. 50.8; D. 27.0 cm
Yale University Art Gallery, Gift of Mrs.
Joseph Marshall Flint (1946.111)

72. Spanish, artist unknown
(2nd half of the 15th century)
*Lawyer (Figure from an Altar
Retable)*
Polychromed wood
H. 68.6 cm
Yale University Art Gallery, Gift of
David H.W. Dohan (1969.108)

73. Spanish, artist unknown
(late 14th or early 15th century)
Processional Cross
Copper gilt
H. 92; W. 46.5 cm
Yale University Art Gallery, Gift of the
Associates in Fine Arts (1938.270)

74. A.W.N. Pugin
(British, 1812–52)
Sketches after the Martyrdom
of St. Erasmus *by Dieric Bouts*
Pen and ink on paper
25.1 x 19.1 cm
Lent by The James M. and Marie-Louise
Osborn Collection, Beinecke Rare Book
and Manuscript Library, Yale University
(Osborn 95.3.3 [113])

75. British, maker unknown
(19th century)
Ecclesiastical Candlestick
Electroplated base metal
H. 68.2, Diam. 21.5; W. 22.3 cm
Lent by Stephen Parks

76. A.W.N. Pugin
(British, 1812–52)
Sketches after the Diptych of
Christiaan de Hondt *by the Master
of Bruges 1499*
Ink and graphite on paper
15.24 x 11.43 cm
Lent by The James M. and Marie-Louise
Osborn Collection, Beinecke Rare Book
and Manuscript Library, Yale University
(Osborn 95.3.3 [112.7])

77. French, maker unknown
(early 13th century)
Chasse *(Reliquary) with Angel
Medallions*
Champleve enamel, gilded copper
H. 17; L. 23.5; W. 8.9 cm
Yale University Art Gallery, Maitland F.
Griggs, B.A. 1896, Fund (1949.101)

78. George Edmund Street
(British, 1824–81)
Design for a Reliquary (ca. 1850)
Watercolor on paper
11.9 x 10.5 cm
Lent by the Yale Center for British Art,
Paul Mellon Collection (B1977.14.1184)

79. George Edmund Street
(British, 1824–81)
*Design for a Communion Set,
for Jones and Willis, Birmingham*
(ca. 1850)
Watercolor and ink on paper
21.1 x 24.4 cm
Lent by the Yale Center for British Art,
Paul Mellon Collection (B1977.14.1169)

80. Francis W. Cooper
(American, active 1842–90)
Chalice (one of a pair from a
communion set)
Silver
H. 23.1; Diam. 12.1 cm
Yale University Art Gallery, Gift of
Frederick R. Kossack (1990.69.1.1)

81. Cooper & Fisher
(Francis W. Cooper
[American, active 1842–90] and
Richard Fisher
[American, dates unknown];
partnership 1854–62)
Paten
Silver
Diam. 25.4 cm.
Yale University Art Gallery, Gift of Alan
R. Kossack (1993.51.106.1)

82. Francis W. Cooper
(American, active 1842–90)
Cruet (ca. 1845; one of a pair
from a communion set)
Silver
H. 23.5; Diam. 7.6 cm
Yale University Art Gallery, Gift of Alan
R. Kossack (1991.34.3.1)

83. A.W.N. Pugin, Designer
(British, 1812–52); manufactured by
Derby Porcelain Works, Derby
Pair of Altar Vases (ca. 1811–48)
Hand painted porcelain
H: 23.5; Diam. 12 cm
Lent by Stephen Parks

80

83

84. Charles Turner
(British, 1773–1857) after
Sir Henry Raeburn
(British, 1756–1823)
Portrait of Sir Walter Scott (1810)
Mezzotint
56.2 x 41.5 cm
Lent by the Yale Center for British Art,
Paul Mellon Collection (B1970.3.612)

85. Edwin Austin Abbey
(American, 1852–1911, M.A.
[Hon.] 1897)
Rebecca and Rowena, from Ivanhoe
Pen and ink on paper
50.8 x 36.2 cm
Yale University Art Gallery, Presented by
the Artist when he received his degree
from the Yale School of Fine Arts in 1902
(1902.1)

86. John Quidor
(American, 1801–81)
*Ichabod Crane Flying from the
Headless Horseman*
Oil on canvas
57.5 x 76.4 cm
Yale University Art Gallery, Mabel Brady
Garvan Collection (1948.68)

87. Sir Edward Coley Burne-Jones
(British, 1833–98)
*Fair Rosamund and Queen
Eleanor* (1861)
Oil on canvas
49.5 x 37.5 cm
Lent by the Yale Center for British Art,
Paul Mellon Collection (B1980.24)

88. Edwin Austin Abbey
(American, 1852–1911, M.A.
[Hon.] 1897)
Goneril and Regan, from King Lear
(Act I, Scene I) (1902)
Oil on canvas
76.8 x 44.5 cm
Yale University Art Gallery, Edwin
Austin Abbey Memorial Collection
(1937.1131)

89. Anglo-Saxon, Kentish,
7th century A.D.
Disk Brooch
Gilded silver with incised niello border
and garnets set in raised gold cells;
bronze hinge and pin
D. 4.55 cm, 0.4 cm thick
Yale University Art Gallery, Stephen
Carlton Clark, B.A. 1903, Fund
(1985.108.1)

90. Eugen Napoleon Neureuther
(German, 19th century)
*Dornroschen. Marchen von Grimm
(Sleeping Beauty. Fairy Tale by
Grimm)* (1836)
Etching
68.8 x 52.2 cm
Yale University Art Gallery, Everett V.
Meeks, B.A. 1901 (Fund, 1996.20.1)

91. John Moyr Smith, Designer
(British, ca. 1845–ca. 1895);
manufactured by Mintons
China Works, Stoke-on-Trent
(British, 1868–1918)
*"Vivien" Fireplace Tile, from
"Idylls of the King" Series* (designed
1873–74; manufactured ca. 1875)
Lead-glazed white earthenware with
underglaze transfer-printed decoration
15.3 x 15.3 cm
Private Collection

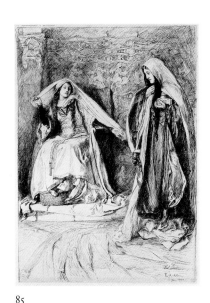

85

92. John Moyr Smith, Designer
(British, ca. 1845–ca. 1895);
manufactured by Mintons
China Works, Stoke-on-Trent
(British, 1868–1918)
*"Morte d'Arthur" Fireplace Tile,
from "Idylls of the King" Series*
(designed 1873–74; manufactured
ca. 1875)
Lead-glazed white earthenware with
underglaze transfer-printed decoration
15.3 x 15.3 cm
Lent by Mr. and Mrs. Richard Derringer

93. John Moyr Smith, Designer
(British, ca. 1845–ca. 1895);
manufactured by Mintons
China Works, Stoke-on-Trent
(British, 1868–1918)
*"Keltic Harp" Decorative Tile, from
"Classical Figures with Musical
Instruments" Series* (designed
1876–77, manufactured ca. 1880)
Lead-glazed white earthenware with
underglaze gold-leaf and transfer-printed
decoration
20.5 x 20.5 cm
Private Collection

94. Walter Crane,
(British, 1845–1915) designed for
The Baby's Opera in 1877;
manufactured by Wheeling Tile
Company, Wheeling, West
Virginia (American, founded 1913)
"Ye Good King Arthur" Cushion Tile
(ca. 1915)
Lead-glazed white earthenware with
underglaze transfer-printed decoration
15.3 x 15.3 cm
Private Collection

95. Edward Hammond, Designer
(British, dates undetermined);
manufactured by Mintons China
Works, Stoke-on-Trent
(British, 1868–1918); retailed by
A.D. Vorce & Co., Hartford,
Connecticut (1856–ca. 1910)
Decorative Tile with Bagpipe Player
(ca. 1880; designed 1872–75)
Lead-glazed white earthenware with
incised and relief decoration
20.3 x 20.3 cm
Private Collection

96. Designed and possibly
decorated by Mintons China
Works, Stoke-on-Trent (British,
1868–1918); tile manufactured by
L. Montereau & Cie., Creil, France,
19th century
*Decorative Tile, "Hawking," from
the Series "Old English Sports and
Games"* (pattern no. 1895, ca. 1882)
Lead glazed earthenware with
underglaze decoration
15 x 15 cm
Lent by Mr. and Mrs. Richard Derringer

97. Designer unknown,
manufactured by Josiah Wedgwood
& Sons, Etruria, Staffordshire
(British, 1870–1900+)
*Decorative Tile with "Ye Church"
and "Ye Army"* (ca. 1878)
Lead glazed white earthenware with
underglaze transfer printed decoration
15.2 x 15.1 cm
Lent by Mr. and Mrs. Richard Derringer

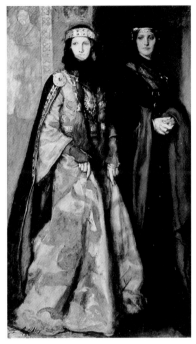

88

79

A Guide to American Gothic
Revival buildings that can
be visited in Connecticut, New
England, and the Northeast.

Itineraries

Susan B. Matheson

David Sikes House, Suffield, Connecticut

The guide is divided into three sections, as described above. The Connecticut section focuses first on New Haven, followed by other cities and towns statewide, arranged alphabetically. New England outside of Connecticut is arranged by state, in an itinerary that starts with Rhode Island, progresses northward and westward through Massachusetts, then north and east through Vermont, New Hampshire, and Maine. Within each state, cities and towns are arranged alphabetically. The third section comprises New York, New Jersey, Pennsylvania, Maryland, and Virginia. Again, communities are listed alphabetically. Street addresses are given when known.

These lists have been compiled from a wide variety of published sources, conversations with specialists, and the author's own travels. Buildings recognized by the New Haven Preservation Trust (NHPT) and those in Connecticut listed in the National Register of Historic Places (NRHP) are indicated as such in their respective entries. The lists are not complete, and the author would welcome information on additional buildings.

Buildings printed in italics are illustrated. References to illustrations of the buildings in the essays are given in square brackets.

Connecticut

City Hall [ill. p. 53]	Henry Austin, 1861 165 Church Street (on the New Haven Green) NHPT Landmark building
Trinity Church on the Green [ill. p. 60]	Ithiel Town, 1813–14 240 Temple Street, South end of the New Haven Green NHPT Landmark building
St. Paul's Episcopal Church	Attributed to Francis Hawks with consultation by Ithiel Town, 1829 620 Chapel Street, Corner of Olive Street NHPT plaqued building
Varick American Zionist Church	1862 242 Dixwell Avenue NHPT plaqued building
Saint Mary's Church	James Murphy, 1860 7 Hillhouse Avenue NHPT plaqued building

St. Casimir's Church, New Haven

Congregational Church of the Redeemer	David R. Brown, 1870, now Trinity Lutheran Church 292 Orange Street NHPT Landmark building
Calvary Baptist Church [ill. p. 66]	Rufus G. Russell, 1871, now Yale Repertory Theater 1120 Chapel Street, Corner of York Street NHPT plaqued building
East Pearl Street Methodist Church	Victorian Carpenter Gothic, 1871 19 East Pearl Street
St. Casimir's Church	Rufus G. Russell, 1872 (originally Davenport Congregational Church) Greene Street, at the corner of Wooster Square

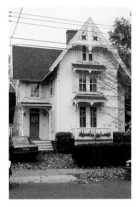

Aaron R. Kilborn House, New Haven

Christ Church	Henry Vaughn, 1895 junction of Whalley Avenue, Elm and Park Streets
Aaron R. Kilborn House	1844 12 Lincoln Street NHPT plaqued building
Whitney Cottage	1850s, apparently originally a cottage on the Eli Whitney, Jr. Estate 9–10 Edgehill Rd.

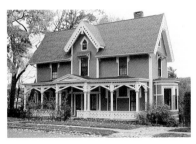

Whitney Cottage, New Haven

Judge Wayland Cottage	1855 (rear addition modern) 135 Whitney Avenue NHPT Landmark building

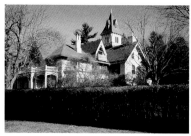

Raynham, New Haven

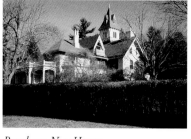

210 St. Ronan Street, New Haven

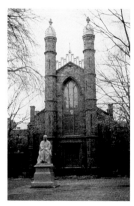

*Richard Everit House,
New Haven*

*Yale University – Library,
now Dwight Hall, New
Haven*

Raynham		1804, Gothicized in 1856/1858 709 Townsend Avenue NHPT Landmark building
Gothic House		1860s 210 St. Ronan Street
James F. Babcock House		1862 89 Sherland Avenue NHPT Landmark building
Richard Everit House		1866–67 641 Whitney Avenue
Herbert Barnes House		1869 1212 Quinnipiac Avenue NHPT plaqued building
Gothic House		1875 114 Kimberly Avenue NHPT plaqued building
Dr. Mary Blair House		1875 154 East Grand Avenue NHPT Landmark Building
John B. Ludington House		1875 43 East Pearl Street NHPT plaqued building
Ed Mansfield Tenant House		Ca. 1875 72 Mansfield Street NHPT plaqued building
Gothic House		Ca. 1875 101 Mansfield Street, moved from another location, probably the corner of Sachem Street
Franklin S. Bradley House		Rufus G. Russell, 1877 1287 Chapel Street NHPT plaqued building
Gothic House		Rufus G. Russell, 1879 131 Sherman Avenue
Grove Street Cemetery		Founded 1796 (various Gothic Revival funerary monuments) Grove Street
Humphrey Street School		Rufus G. Russell, 1877, now the Polish National Home 291 Humphrey Street
Yale University – Library, now Dwight Hall		Henry Austin, 1842 67 High Street, on the Old Campus NHPT Landmark building

– Towers from Alumni Hall [ill. p. 57]	A.J. Davis, 1851–53, moved to present location in 1911 when Alumni Hall was demolished 66 High Street, or from the Yale Art Gallery Sculpture Court
– Yale School of Fine Arts, now Street Hall [ill. p. 56]	Peter Bonnett Wight, 1864 1071 Chapel Street, Corner of Chapel and High Streets
– Battell Chapel	Russell Sturgis, 1874 400 College Street NHPT plaqued building
– Harkness Tower and Memorial Quadrangle, remodelled as Branford College	James Gamble Rogers, 1917–21 (Tower and Quadrangle) and 1933 (College)
– Sterling Memorial Library	James Gamble Rogers, 1927 West end of Cross Campus

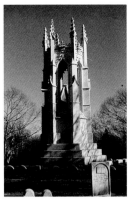

Monument to Henry K. Harral, Bridgeport

Beyond New Haven

Ansonia

Christ Church	H.M. Congdon, ca. 1850 56 South Cliff Street

Bridgeport

Monument to Henry K. Harral	A.J. Davis, 1854 Bridgeport Cemetery

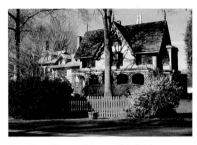

Jonathan Sturges House, Fairfield

Fairfield

Jonathan Sturges House	Joseph Collins Wells, 1840 449 Mill Plain Road, facing Mill Plain Green

Guilford

James Monroe House	1850 Fair Street

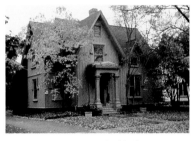

James Monroe House, Guilford

Hartford

Christ Church Cathedral	Ithiel Town, 1827–29 45 Church Street, corner of Main Street
Wadsworth Atheneum [ill. p. 55]	Ithiel Town, A.J. Davis, and Henry Austin, 1842–49 600 Main Street
State Capitol Building [ill. p. 52]	Richard Michell Upjohn, 1875 210 Capitol Avenue National Historic Landmark
Trinity College Quadrangle	William Burges, 1874 300 Summit Street

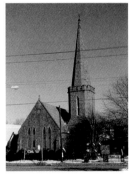

St. Peter's Church, Milford

Middletown

Edward Duane Barnes House	Probably designed by Edward Duane Barnes, 1846 327 High Street

Milford

St. Peter's Church	Frank Wills, 1851 71 River Street

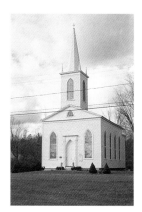

Trinity Church, Milton

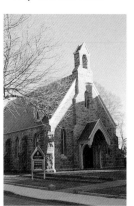

Calvary Church, Stonington

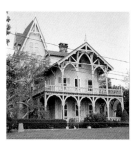

Villa Vista, Stony Creek

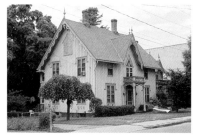

Henry Graham Thompson House,
Thompsonville

Milton
Trinity Church

Oliver Dickinson, Builder, 1802
Milton Road, on the Green

New London
St. James's Church
[ill. p. 76]

Richard Upjohn, 1851
76 Federal Street

Noank
James A. Latham House

1853

Norwich
Christ Church

Richard Upjohn, 1846–49
78 Washington Street

Quaker Farms
Christ Episcopal Church

1811–14
470 Quaker Farms Road

Riverton
Union Episcopal Church

1829, now the Hitchcock Museum
1 Robertsville Road

South Windsor
Charles Green House
[ill. p. 46]

A. J. Davis, 1851
660 Main Street

Stonington
Calvary Church

Richard Upjohn, 1847–49
27 Church Street

Stony Creek
"Villa Vista"

Henry Austin, 1878
32 Prospect Hill Road

Somers
Kibbe House

Ca. 1843

Suffield
David Sikes House
[ill. p. 80]

Ca. 1835
1425 Mapleton Avenue

Thompson
William Mason House
[ill. p. 39]

After A.J. Downing, 1845
20 Chase Road, on the Green

Thompsonville
Henry Graham Thompson House

A.J. Davis, 1845
Prospect Street

Windham
St. Paul's Church

27 Plains Road

Windsor Locks
Gothic House

After A.J. Downing, 1868
16 Church Street

Woodstock
Roseland Cottage
[ill. p. 48]

Joseph C. Wells, 1846,
for Henry Chandler Bowen
On the Green

Rhode Island

Newport
Kingscote Richard Upjohn, 1839,
 for George Noble Jones

Gothic Room, Marble House Richard Morris Hunt, 1895

Jonathan Prescott Hall House A.J. Davis, 1848–50
 Malbone Road

New York Yacht Club Attributed to A.J. Davis, 1845
 New York Yacht Club property,
 on the harbor (moved from
 Mystic, Connecticut, 1999)

Providence
St. John's Cathedral John Holden Greene, 1810–11
 271 N. Main Street

Grace Church Richard Upjohn, 1845–46
 175 Mathewson Street

St. Stephen's Church Richard Upjohn, 1860–62
 114 George Street

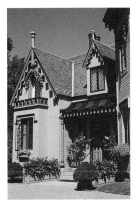

Kingscote, Newport

Massachusetts

New Bedford
William J. Rotch House A.J. Davis, 1844
 originally 7 Orchard Street
 (now 19 Irving Street)

James H.C. Richmond House Possibly after A.J. Davis,
 plans/design 1856(?)
 7 Irving Street

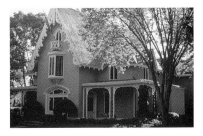

William J. Rotch House, New Bedford

Samuel Lumbard House 1847
 163 Cottage Street

First Congregational Church A.J. Davis & Warren, 1835–38
(Now Unitarian) Union and Eighth Streets

Boston
Grace Church William Washburn, 1835
 Temple Street

Brookline
St. Paul's Church Richard Upjohn, 1848–52
 (altered in restoration after fire)
 15 St. Paul Street

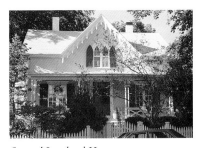

*Samuel Lumbard House,
New Bedford*

Cambridge
First Parish Church Isaiah Rogers, 1833
 3 Church Street

Bigelow Chapel Dr. Jacob Bigelow, 1843, rebuilt 1858
 Mount Auburn Cemetery

Granville
Board-and-batten house Ca. 1850
 Route 57

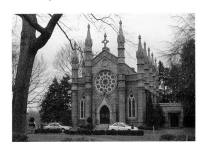

Bigelow Chapel

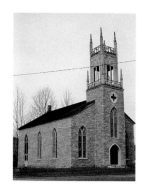

St. Luke's Church, Lanesboro

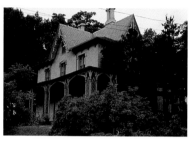

John Angier House, Medford

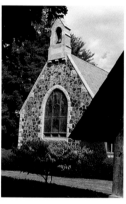

Christ Church, Sheffield

Justin Smith Morrill House, Strafford

Great Barrington
Collins House

1851
Route 7

Lanesboro
St. Luke's Church

1836
Route 7

Martha's Vineyard
Cottages

Wesleyan Grove, Oak Bluffs, ca. 1866

Medford
John Angier House

A.J. Davis & John Angier, 1842–44
129 High Street

Grace Episcopal Church

H.H. Richardson, 1872
160 High Street

North Easton
Oakes Angier Ames House

After A.J. Downing, 1854

Plymouth
Christ Church

Richard Upjohn, 1846
149 Court Street

Salem
St. Peter's Church

Gridley J.F. Bryant, 1837
now the Salem Witch Museum
19 1/2 Washington Square North

Henry Mason Brooks House

After A.J. Downing, 1851
260 Lafayette Street

Sheffield
Christ Church

1911
Route 7

Vermont

Arlington
St. James's Church

William Passman, 1829
74 Church Street

Castleton
James Hope House

Probably James Hope, ca. 1850

Montpelier
Thomas Waterman Wood
House, "Athenwood"

Probably T.W. Wood, built 1850

South Royalton
D. Flanders House

1864

Strafford
Justin Smith Morrill House

Designed by Morrill
(after A.J. Downing), 1848–53
Justin Smith Morrill Highway

Windsor
McIndoe House

1849
Court Street

New Hampshire

Canaan
Old North Church 1828
 Canaan Street

Charlestown
St Luke's Church Richard Upjohn, 1863, enlarged by
 Richard Michell Upjohn, 1869
 Main Street

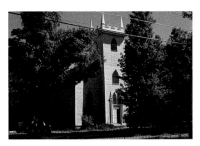

Old North Church, Canaan

Concord
Joseph B. Walker Cottage Based on A.J. Downing design
 North Main Street

Greenville
Deacon Merrill C. Dodge 1850
House 66 Main Street

Hopkinton
St. Andrew's Church John Leach, 1827–28
 354 Main Street

Lancaster
St. Paul's Church 1875
 Main Street

Manchester
Grace Church Richard Upjohn and
 Richard Michell Upjohn, 1860
 106 Lowell Street

Peterborough
Gothic Cottage ca. 1845
 60 Grove Street

Gothic Cottage ca. 1850

Stoddard
Congregational Church 1835
 Route 123

Village of Drewsville
St. Peter's Church 1836
 On the Village Green

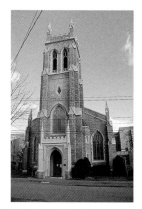

St. John's Church, Bangor

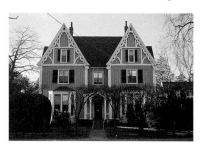

Henry Boody House, Brunswick

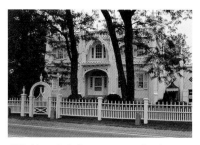

"Wedding Cake" House, Kennebunk

Maine

Bangor
St. John's Church Richard Upjohn, 1836–39
 234 French Street

Bath
Grace Church Richard Upjohn, 1852
 1100 Washington Street

United Church of Christ 1843
 Winter Street

"Chocolate" Church 1846, now an Arts Center
 804 Washington Street

Brunswick
Bowdoin College
Henry Boody House Gervase Wheeler, 1849
 256 Maine Street

First Parish Congregational Richard Upjohn, 1845–45 (tower altered)
Church 9 Cleaveland Street

St. Paul's Church Richard Upjohn, 1845
 27 Pleasant Street

Calais
"Gilmore" Davis/Downing Style, ca. before 1870
 316 Main Street

"Washburn" Davis/Downing Style, ca. before 1870
 318 Main Street

Gardiner
"Oaklands" Richard Upjohn, 1835–36
 for R.H. Gardiner

Kennebunk
"Wedding Cake" House Original House, 1826; Gothic "frosting,"
 George W. Bourne, 1855;
 Gothic barn, ca. 1850–55
 Summer Street

Portland
John J. Brown House Henry Rowe, 1845
 387 Spring Street

United Methodist Church Charles A. Alexander, 1856
 17 Chestnut Street

New York

New York City
Trinity Church Richard Upjohn, 1840–46
 Broadway and Wall Streets

St. Patrick's Cathedral James Renwick Jr., 1858–79
 Fifth Avenue

First Presbyterian Church Frederick C. Wells, 1845
 12 West 12th Street

Church of the Ascension Richard Upjohn, 1840–41
 5th Avenue and 10th Street

Church of the Holy Richard Upjohn, 1846
Communion 6th Avenue and 20th Street

Grace Church James Renwick, Jr., 1846
[ill. p. 90] Broadway and 10th Street

Brooklyn
Christ Church Richard Upjohn, 1841–42

Grace Church Richard Upjohn, 1849
 254 Hicks Street, Brooklyn Heights

Greenwood Cemetery Richard Upjohn, 1861
 (Main Gate and Gatehouse)
 5th Avenue at 25th Street

Brooklyn Bridge John Roebling, 1883

New Rochelle
Lawrence M. Davenport Cottage A.J. Davis, 1859–60,
 wing added by Davis, 1871–74,
 later additions by others
 Davenport Neck

Trinity Church Richard Upjohn, 1863
 311 Huguenot Street

Rye
William P. Chapman House A.J. Davis, 1852–55
 now Rye Country Club
 Whitby, Boston Post Road

Hudson River Valley

Bedford Hills, near Mount Kisco
Henry Wood House A.J. Davis, 1846
 Croton Lake Road

Dobbs Ferry
Edwin B. Strange House, A.J. Davis, 1854–57
"Ingleside" Broadway, now main building
 of St. Christopher's School

Garrison-on-Hudson
Edwards Pierrepont House, A.J. Davis, 1863–66
"Hurstpierrepont"

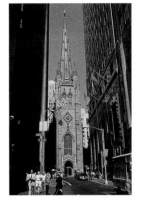

Trinity Church, New York City

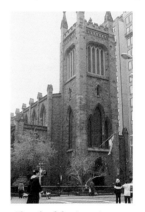

*Church of the Ascension,
New York City*

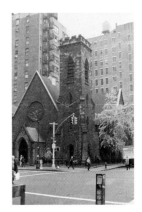

*Church of the Holy Communion,
New York City*

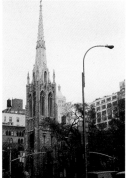

Grace Church, New York City

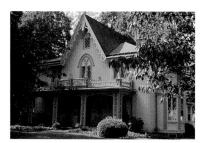

Henry Delamater House, Rhinebeck

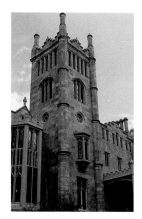

Knoll / Lyndhurst, Tarrytown

Hastings-on-Hudson
First Reformed Church,
Chapel

A.J. Davis, 1869
18 Farragut Avenue

Highland Falls
Church of the Holy
Innocents

Robert Weir, 1846–47
112 Main Street

Hillsdale
Norton S. Collin House

1845–50

Rhinebeck
Henry Delamater House

A.J. Davis, 1844
44 Montgomery Street

Tarrytown
Knoll / Lyndhurst

A.J. Davis, 1838–42 (Knoll); 1864–67
(Lyndhurst)
635 South Broadway

Tompkins Cove, Stony Point
Boulderberg Mansion

1858
Boulderberg Road

Upstate NY

Albany
St. Peter's Church

Richard Upjohn, 1859–60
107 State Street

Amenia
St. Thomas's Church

Richard Upjohn, 1849–51
Leedsville Road

Binghamton
Christ Church

Richard Upjohn, 1853–55
187 Washington Street

Buffalo
St. Paul's Cathedral

Richard Upjohn, 1851,
restored after fire, 1885
128 Pearl Street

Copake Falls
Church of St. John
in the Wilderness

Richard Upjohn, 1851–52
Route 343

Hamilton
St. Thomas's Church

Richard Upjohn, 1847
12 ½ Madison Street

Oneida
Niles Higinbotham House

A.J. Davis 1849–50
("Cottage Lawn", and summerhouse)
435 Main Street

Rochester
Ellwanger and Barry
Mt. Hope Nursery Office

A.J. Davis, 1854–57, 1858–59
(Now owned by the
University of Rochester)
Mount Hope Avenue

Third Presbyterian Church

Richard Upjohn, 1859
4 Meigs Street

St. Luke's and St. Simon of Cyrene Episcopal Church	Josiah Brady, 1824–28 17 South Fitzhugh Street

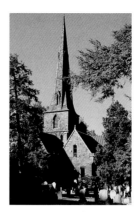

Rome
Zion Church — Richard Upjohn, 1850–51
140 West Liberty Street

Skaneatales
E. Reuel Smith House — A.J. Davis, 1850
11 West Lake Road

St. Mary's Church, Burlington

Troy
Church of the Holy Cross — A.J. Davis and Nathan B. Warren, 1843–44, much altered, additions by Upjohn (1848) and Dudley, (including Organ Case and stalls) 142 Eighth Street

St. Paul's Episcopal Church — 1826–28, after Ithiel Town, Trinity Church, New Haven, Connecticut 58 Third Street

Warsaw
Trinity Church — Richard Upjohn, 1854
62 West Buffalo Street

"The Hermitage," Ho-Ho-Kus

New Jersey

Boonton
St. John's Church — Richard Upjohn and Richard Michell Upjohn, 1863
226 Cornelia Street

Burlington
St. Mary's Church — Richard Upjohn, 1846–48
145 West Broad Street

Camden
St. Paul's Church — 1834–35, attributed to John Notman
422 Market Street

Ho-Ho-Kus
"The Hermitage" — Built ca. 1760; remodeled by William Ranlett as Gothic Revival, 1845
335 N. Franklin Turnpike

Millburn
St. Stephen's Church — 1853
119 Main Street

Spotswood
St. Peter's Church — 1849
505 Main Street

West Orange
Joseph Howard House, "Castlewood" — A.J. Davis, 1857–59 (also coach house)
Mountain Avenue, Llewellyn Park

Edward W. Nichols Cottage — A.J. Davis, 1858–59
Oak Bend, Llewellyn Park

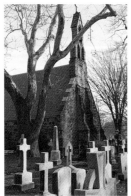

St. James-the-Less Church, Philadelphia

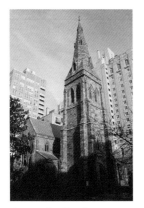

St. Mark's Church, Philadelphia

Virginia Military Institute, Lexington

Pennsylvania

Philadelphia

St. James-the-Less Church	1846–49 North of Fairmount Waterworks, near Laurel Hill Cemetery
St. Mark's Church	John Notman, 1847–49 1625 Locust Street
St. Stephen's Church	William Stricklaw, 1822 19 South 10th Street

Waterford

St. Peter's Church	Possibly Bishop John Henry Hopkins, 1831 100 East Third Street

Maryland

Baltimore

St. Alphonsus's Church	Robert Cary Long, Jr., 1842–43 114 West Saratoga Street
Franklin Street Presbyterian Church	Robert Cary Long, Jr., ca. 1844 corner of Franklin and Cathedral Streets

Frederick

All Saints' Church	Richard Upjohn, 1855 108 West Church Street

Reistertown

St. Michael's Chapel	Richard Upjohn, 1853 Hannah More Academy

Westminster

Church of the Ascension	Robert Cary Long, Jr., ca. 1845 23 North Court Street

Virginia

Lexington

Virginia Military Institute	A.J. Davis, Barracks 1850, Superintendent's House 1860, Mess Hall
Philip St. George Cocke House, "Belmead"	A.J. Davis, 1845–48 on the James River, Powhatan County
Charles E. Miller House, "Chalk Level"	A.J. Davis, 1848 Pittsylvania County
Charles Bruce House "Staunton Hill"	John E. Johnson, 1848 Charlotte County

General works on the Gothic Revival overall, and in Britain particularly, must begin with Charles Locke Eastlake's *A History of the Gothic Revival* (London, 1872) and Kenneth Clark's *The Gothic Revival: An Essay in the History of Taste* (London, 1928), which have decisively set the tone for all subsequent studies. Georg Germann's *Gothic Revival in Europe and Britain: Sources, Influences and Ideas* (London, 1972) explores a broader national and philosophical context for the movement. Among the most recent studies, Chris Brooks's *The Gothic Revival* (London, 1999) and Megan Aldrich's *Gothic Revival* (London, 1994) provide a comprehensive treatment, while James Massey and Shirley Maxwell's *Gothic Revival* (New York, 1994) is an accessible handbook to its issues and monuments. Important chapters appear in two volumes of the Pelican History of Art, John Summerson's *Architecture in Britain, 1530–1830*, 9th ed. (New Haven and London, 1993), and Henry-Russell Hitchcock's *Architecture: Nineteenth and Twentieth Centuries*, 4th ed. rev. (New Haven and London, 1992).

On Gothic Survival and eighteenth-century "Gothick," see the opposing viewpoints in Michael McCarthy's *The Origins of the Gothic Revival* (London, 1987), and Giles Worsley's "The Origins of the Gothic Revival: A Reappraisal," in *Transactions of the Royal Historical Society*, 6th ser., 3 (1993), 105–151.

Gothic's association with Romanticism is discussed in Agnes Eleanor Addison's *Romanticism and the Gothic Revival* (Philadelphia, 1938); Hugh Honour's *Romanticism* (New York, 1979); and William Vaughan's *Romanticism and Art* (London, 1994).

The major works on Gothic in the Victorian age include Henry-Russell Hitchcock, *Early Victorian Architecture in Britain* (New Haven, 1954); Peter Ferriday, ed., *Victorian Architecture* (London, 1963); George L. Hersey, *High Victorian Gothic: A Study in Associationism* (Baltimore, 1972); Stefan Muthesius, *The High Victorian Movement in Architecture, 1850–1870* (London and Boston, 1972); and Roger Dixon and Stefan Muthesius, *Victorian Architecture*, 2nd ed. (London, 1985).

On Pugin, see Benjamin Ferrey, *Recollections of A.N. Welby Pugin, and his Father, Augustus Pugin; With Notices of their Works* (London, 1861); Michael Trappes-Lomax, *Pugin: A Mediaeval Victorian* (London, 1932); Phoebe Stanton, *Pugin* (London, 1971); Alexandra Wedgwood, with Christopher Wilson, *Catalogue of the Drawings Collection of the Royal Institute of British Architects: The Pugin Family* (Farnborough, Hants., 1977); Alexandra Wedgwood, *A.W.N. Pugin and the Pugin Family. Catalogues of the Architectural Drawings in the Victoria and Albert Museum* (London, 1985); Paul Atterbury and Clive Wainwright, eds., *Pugin: A Gothic Passion* (London and New Haven, 1994); and Paul Atterbury, ed., *A.W.N. Pugin: Master of Gothic Revival* (New Haven, 1995).

Monographs on other individual British architects include (alphabetically by artist): Paul Thompson, *William Butterfield* (Cambridge, Mass., 1971); Kerry Downes, *Hawksmoor* 2nd ed. (Cambridge, Mass., 1980); Michael I. Wilson, *William Kent: Architect, Designer, Painter, Gardener, 1685–1748* (London, 1984); David Cole, *The Work of Sir Gilbert Scott* (London, 1980); David B. Brownlee, *The Law Courts: The Architecture of George Edmund Street* (New York and Cambridge, Mass., 1984); Margaret Whinney, *Wren* (London, 1971); Antony Dale, *James Wyatt* (Oxford, 1956); and Derek Linstrum, *Sir Jeffry Wyatville: Architect to the King* (Oxford, 1972).

Suggested Reading

Relevant primary sources for the Gothic Revival in Britain include: William Dugdale, *The History of St. Paul's Cathedral in London, from Its Foundation untill These Times* (London, 1658); Batty and Thomas Langley, *Ancient Architecture Restored, and Improved* (London, 1742) revised and published as *Gothic Architecture, Improved by Rules and Proportions* (London, 1747); Christopher Wren the Younger, *Parentalia, or, Memoirs of the Family of the Wrens* (London, 1750); Thomas Chippendale, *The Gentleman and Cabinet-Maker's Director* (London, 1754); Horace Walpole, *A Description of the Villa of Mr. Horace Walpole* (Twickenham, 1784); Thomas Rickman, *An Attempt to Discriminate the Styles of English Architecture, from the Conquest to the Reformation* (London, 1817); James Malton, *A Collection of Designs for Rural Retreats as Villas. Principally in the Gothic and Castle Styles of Architecture* (London, 1802, revised 1804); Augustus Charles Pugin, with E.J. Willson, *Specimens of Gothic Architecture* (London, 1821–23); John Rutter, *Delineations of Fonthill and Its Abbey* (Shaftesbury and London, 1823); John Claudius Loudon, *Encyclopaedia of Cottage, Farm, and Villa Architecture and Furniture* (London, 1833, with Supplement, 1842); A.W.N. Pugin, *Contrasts* (London, 1836); idem., *The True Principles of Pointed or Christian Architecture* (London, 1841); idem., *An Apology for the Revival of Christian Architecture in England* (London, 1843); idem., *Glossary of Ecclesiastical Ornament and Costume* (London, 1844); John Ruskin, *The Seven Lamps of Architecture* (London, 1849); idem., *The Stones of Venice* (London, 1851–53); George Edmund Street, *Brick and Marble in the Middle Ages: Notes of a Tour in the North of Italy* (London, 1855); and George Gilbert Scott, *Remarks on Secular and Domestic Architecture, Present and Future* (London, 1857).

Primary sources for Gothic Revival architecture in America include: Andrew Jackson Downing, *Treatise on Landscape Gardening* (New York, 1841); idem, *Cottage Residences* (New York and London, 1842); idem, *The Architecture of Country Houses* (New York, 1850, reprinted New York, 1969); G.W. Curtis, ed., *Rural Essays* (New York, 1852), essays by A.J. Downing originally published in the *Horticulturalist*; Alexander Jackson Davis, *Rural Residences* (New York, 1837); Richard Upjohn, *Upjohn's Rural Architecture* (New York, 1852); Robert Dale Owen, *Hints on Public Architecture* (New York, 1849); Calvert Vaux, *Villas and Cottages* (New York, 1857); B. Talbert, *Gothic Forms Applied to Furniture, Metal Work, and Decoration for Domestic Purposes* (1867, reprinted Boston, 1873). Although published in England, John Claudius Loudon's *Encyclopedia of Cottage, Farm, and Villa Architecture* (London 1833), was influential on both Downing and Davis.

Among secondary sources on American Gothic architecture, the most comprehensive surveys are William H. Pierson, Jr., *Technology and the Picturesque, The Corporate and Early Gothic Styles* (*American Buildings and Their Architects*, vol. 2; Garden City, 1978 repr. New York 1986), with excellent chapters on many of the issues and architects listed below, and Calder Loth and Julius Sadler, Jr., *The Only Proper Style. Gothic Architecture in America* (Boston, 1975), an excellent source of illustrations. On Gothic Revival church architecture and the Ecclesiological movement, see Phoebe B. Stanton, *The Gothic Revival and American Church Architecture. An Episode in Taste 1840–1856* (Baltimore, 1968, 2nd edition, 1997). On Collegiate Gothic, see Paul Venable Turner, *Campus: An American Planning Tradition* (Cambridge, Mass., 1984). Carpenter Gothic is ably represented by Alma deC. McArdle and Deirdre Bartlett McArdle, *Carpenter Gothic: Nineteenth-Century Ornamental Houses in New England* (New York, 1978). New Haven examples are featured in Elizabeth Mills Brown, *New Haven: A Guide to Architecture and Urban Design* (New Haven, 1976, reprinted, 1999); Connecticut buildings will be included in Brown's forthcoming Survey of Connecticut architecture. On Pugin's influence on American Gothic Revival architecture, see Margaret Henderson Floyd, "A.W.N. Pugin and the Gothic Movement in North America," in Paul Atterbury, ed., *A.W.N. Pugin: Master of Gothic Revival* (New Haven and London, 1995), 201–221.

Monographs on prominent American architects working in Gothic Revival style include:

Ralph Adams Cram: Douglass Shand-Tucci, *Ralph Adams Cram: Life and Architecture,* volume 1 of a series in progress (Amherst, 1994)

James Dakin: Arthur Scully, Jr., *James Dakin, Architect: His Career in New York and the South* (Baton Rouge, 1973).

A.J. Davis: Amelia Peck, ed., *Alexander Jackson Davis, American Architect 1803–1892* (New York, 1992), with a list of Davis's works by Jane B. Davies. On Knoll/ Lyndhurst, see Amelia Peck, *Lyndhurst: A Guide to the House and Landscape* (Tarrytown, 1998), and William H. Pierson, Jr., *Technology and the Picturesque, The Corporate and Early Gothic Styles* (*American Buildings and Their Architects*, vol. 3; Garden City, 1978 repr. New York 1986), 308–348 (on Davis as a whole, 270–348); On Davis's furniture, see Jane B. Davies, "Gothic Revival Furniture Designs of Alexander Jackson Davis," *The Magazine Antiques* vol. 3, no. 5 (May, 1977), 1014–1027.

A.J. Downing: George B. Tatum and Elizabeth Blair Macdougall, *Prophet with Honor: The Career of Andrew Jackson Downing, 1815–1852* (Washington, 1989); David Schulyer, *Apostle of Taste: Andrew Jackson Downing, 1815–1852* (Baltimore, 1996); Judith K. Major, *To Live in the New World: A.J. Downing and American Landscape Gardening* (Cambridge, Mass., 1997).

Frank Furness: James O'Gorman, *The Architecture of Frank Furness* (Philadelphia, 1973); George E. Thomas, Michael J. Lewis, and Jeffrey A. Cohen, *Frank Furness. The Complete Works* (Princeton, 1996).

John Notman: Constance M. Greiff, *John Notman, Architect 1810–1865* (Philadelphia, 1979).

James Renwick, Jr.: William H. Pierson, Jr., *Technology and the Picturesque, the Corporate and the Early Gothic Styles* (*American Buildings and Their Architects*, vol. 3; Garden City, 1978, reprinted New York, 1986), chapter 5.

H.H. Richardson: Henry-Russell Hitchcock, *The Architecture of H.H. Richardson and his Times* (Cambridge, Mass., 1966); Jeffrey Karl Ochsner, *H.H. Richardson: Complete Architectural Works* (Cambridge, Mass., 1982).

James Gamble Rogers: Patricia D. Pierce, *Sparing No Detail: The Drawings of James Gamble Rogers for Yale University, 1913–1935* (New Haven, 1982); Aaron Betsky, *James Gamble Rogers and the Architecture of Pragmatism* (Cambridge, Mass., 1994)

Ithiel Town and A.J. Davis: Roger Hale Newton, *Town and Davis, Architects: Pioneers in American Revivalist Architecture* (New York, 1942).

Richard Upjohn: Everard M. Upjohn, *Richard Upjohn, Architect and Churchman* (New York, 1939).

P.B. Wight: Sarah Bradford Landau, *P.B. Wight: Architect, Contractor, and Critic, 1838–1925,* exhibition, Art Institute of Chicago, January 2–July 31, 1981 (Chicago, 1981).

Calvert Vaux: William Alex, *Calvert Vaux, Architect and Planner* (New York, 1994); Francis R. Kowsky, *Country, Park, and City: The Architecture and Life of Calvert Vaux* (Oxford, 1998)

On the Gothic Revival in continental Europe, see George Germann, *The Gothic Revival in Europe and Britain: Sources, Influences, and Ideas* (Cambridge, Mass., 1972); Nikolaus Pevsner, *Ruskin and Viollet-le-Duc: Englishness and Frenchness in the Appreciation of Gothic Architecture* (London, 1969). Several exhibitions focusing on the Gothic Revival on the Continent have taken place in Europe, including *Neo-Gotiek in Belgie* (Ghent, 1994) and *De Lelijke Tijd* (Amsterdam, 1995–96).

On Gothic literature, the following surveys also include additional references: Montague Summers, *The Gothic Quest. A History of the Gothic Novel* (London, 1938, reprinted New York, 1964); David Punter, *The Literature of Terror. A History of Gothic Fiction from 1765 to the Present Day* (London, 1980); Fred Botting, *Gothic* (London, 1996). See also Siegbert Salomon Prawer, *Caligari's Children. The Film as Tale of Terror* (Oxford, 1980); Kate Ferguson Ellis, *The Contested Castle: Gothic Novels and the Subversion of Domestic Ideology* (Urbana and Chicago, 1987); A. Tudor, *Monsters and Mad Scientists. A Cultural History of the Horror Movie* (Oxford, 1989); and Victor Sage and Allan Lloyd Smith, *Modern Gothic: A Reader* (Manchester, 1996). Extensive material may also be found on such Gothic novelists as Horace Walpole, William Beckford, and Sir Walter Scott.

Designed by Nathan Garland and set in Adobe Garamond.

The title typography alternates an early Fraktur design that was revived
in 19th-century Munich by the Genzsch & Heyse foundry with Univers 57,
a contemporary sans serif type that was designed by Andre Frutiger
in 1957 for the Deberny & Peignot foundry in Paris.

Printed by Hull on paper that is free of acids, dioxins, and chlorine.